IMAGES
of America

KENNYWOOD

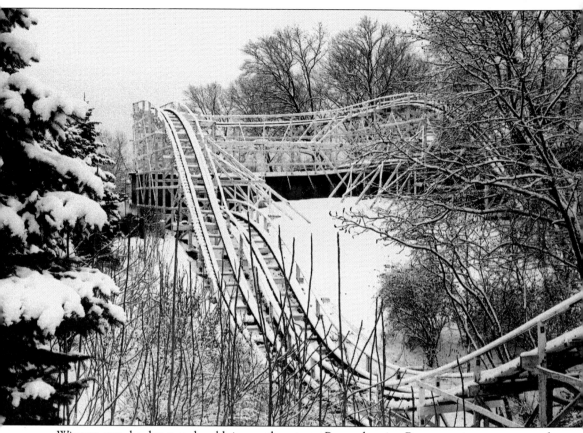

Winters can be long and cold in southwestern Pennsylvania. But even in snow-covered splendor, one can almost hear the screams of summer that will once again emanate from the Jack Rabbit roller coaster at Kennywood, a more-than-century-old traditional amusement park near Pittsburgh. Although all of the park's rides are in hibernation until warmer weather arrives, all is not peaceful. Workers fervently prepare and refurbish just about everything in readiness for the day when the park gates will reopen to thousands of area thrill seekers. Kennywood's opening day in mid-spring will once again herald in a new season of thrills and laughter at "America's Finest Traditional Amusement Park." So hang on tight, the fun is about to begin! (Photograph by David Hahner.)

IMAGES
of America

KENNYWOOD

David P. Hahner Jr.
Foreword by Carl O. Hughes

ARCADIA
PUBLISHING

Published by Arcadia Publishing
Charleston, South Carolina

Printed in the United States of America

Library of Congress Catalog Card Number: 2004100869

For all general information contact Arcadia Publishing at:
Telephone 843-853-2070
Fax 843-853-0044
E-mail sales@arcadiapublishing.com
For customer service and orders:
Toll-Free 1-888-313-2665

Visit us on the Internet at www.arcadiapublishing.com

To my late grandfather, Andrew Townsend, who worked at Kennywood when I was a child and started my passion with amusement parks; to my parents, Kathleen and David, who nurtured that passion while I was young with many visits to Kennywood and other amusement parks; to my wife, Theresa, who lovingly puts up with my obsession; and especially to my young son, David, who has inherited the mania worse than I!

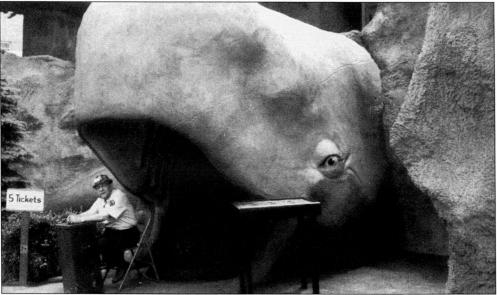

In this 1969 photograph, my grandfather, Andrew Townsend, waits to collect tickets from guests who dare to enter through the large blue whale's mouth into the newly renovated Noah's Ark fun house. It was his love for the park, and especially Noah's Ark, that truly inspired my own passion for not only Kennywood but also amusement parks in general. For that, I am eternally grateful. (Margaretta Townsend Collection.)

CONTENTS

ACKNOWLEDGMENTS

This book required a lot of help from many people and sources. Most of the photographs come straight from the Kennywood archives. The generosity and support I received from the park's staff was so helpful and inspiring that without them this book would most certainly have never been created. My thanks go to everyone there, especially Mary Lou Rosemeyer, who asked me if I would be interested in doing this book and who has helped me procure pictures and information for it. Also, a huge thank you goes to Marie Riles, archivist at the park. Her dedication to preserving and categorizing the park's history is truly remarkable, and her assistance in obtaining and scanning many of the photographs for use in the book earns my sincerest appreciation and respect. Others at the park who have helped in some way include Jeff Checcio, Rob Henninger, and Gary Janchenko. My thanks also go to company chairman Harry W. Henninger, company president Pete McAneny, park manager Jerome Gibas, and marketing director Keith Hood for allowing me to write this book. And extra thanks go to Carl O. Hughes, chairman emeritus of Kennywood Entertainment, who not only agreed to write the foreword for the book but also invited me to his home and gave me priceless information that I could use within the pages from his more than 50 years of experience at the park.

Other friends, family, and colleagues have also helped tremendously with information, photographs, postcards, and other helpful tidbits that found their way into the pages. A very big thank you goes to Jim Futrell, historian for the National Amusement Park Historical Association, who not only encouraged me to write this book but also helped with photographs, postcards, proofreading, and valuable information concerning the history of the park. Rick Davis and Sarah Windisch of the Darkride and Funhouse Enthusiasts also provided priceless information about the park's dark rides and fun houses. In addition, Rick provided many photographs and was a tremendous help with scanning and research. Others who I would like to thank include Dick Bowker with his unparalleled postcard collection; artist Linda Barnicott for use of her beautiful renderings of the park; Charles Siple, who as a young man took some wonderful photographs of the park in 1938; and co-workers Dave Adams and Gary Koch for help on photograph scanning. I would also like to thank my parents, Kathy and Dave Hahner, and my brother Tom Hahner who helped with proofing and photograph acquisition. Thanks also go to my brother Bill Hahner and sister, Kelly Trautman, for their encouragement and support. And a huge thanks to my grandmother, Margaretta Townsend, who lent me a very special and personal picture for the book. And lastly, but certainly far from least, I would like to thank my wife, Theresa, who helped me in almost every phase of the project, including proofing, and to my young son, David, who lost his father to the book for four months.

Most photographs in this book are from the Kennywood archives, unless otherwise noted. Garfield and Odie appear courtesy of Paws.

Bibliography

Cartmell, Robert. *The Incredible Scream Machine: A History of the Roller Coaster*. Amusement Park Books, 1987.

Futrell, Jim. *Amusement Parks of Pennsylvania*. Mechanicsburg, Pennsylvania: Stackpole Books, 2002.

Jacques, Charles J. Jr. *Kennywood: Roller Coaster Capital of the World*. Vestal, New York: Vestal Press, 1982.

Jacques, Charles J. Jr. *More Kennywood Memories*. Jefferson, Ohio: Amusement Park Journal, 1998.

FOREWORD

The opening of a new amusement park in the Pittsburgh area did not attract much attention in 1898. After all, there were a dozen others, some already built and more to come.

Besides, it was a time of competing excitement, whether following the exploits of Teddy Roosevelt and his Rough Riders or just enjoying and contemplating the relatively new miracle of electricity. It was electricity, you see, that took the Monongahela Street Railways' open summer cars to the new park, Kennywood, at the end of the trolley line.

What transition and excitement that park has seen since. Not so much in its attractions—the merry-go-round was around from the beginning and was soon followed by roller coasters—but in America's life and times during the past 100-plus years, an unprecedented period of progress.

There are few families living without electricity today. If the power fails for just a few hours, we are upset. I remember my grandfather (in the 1920s) reading by kerosene lamp. Indoor plumbing was a luxury he and many others did not have. Kennywood's first parking lot was for horses and buggies. George Washington had the same transportation. Computers, airplanes, cell phones, sport-utility vehicles, microwaves, televisions—what were those?

Despite all the change, Kennywood has survived, providing the same clean, albeit more thrilling, family fun that it did originally. What other major amusement park still allows picnic baskets?

No wonder it is "America's Finest Traditional Amusement Park!" It is now and will continue to be.

So thanks, Pittsburgh. You have been wonderful. We love you all.

—Carl O. Hughes

Kennywood is an amusement park that is steeped in tradition. From the moment you walk through the front gates and emerge through the entrance tunnel under the highway, you know you have entered a special place. Here, attractions that thrilled our parents, grandparents, and even great-grandparents still delight riders today. This splendid mixture of old and new attractions is so distinctive that Kennywood was designated a National Historic Landmark by the National Park Service in 1987. This honor is proudly displayed at the park's main entrance. (Photograph by David Hahner.)

INTRODUCTION

It would be difficult, at best, to find someone who has either grown up or lived in the Pittsburgh area who has never heard of or visited Kennywood Park. This old-fashioned, traditional amusement park has been thrilling millions of Pittsburgh-area residents since it opened in 1898. It has been an area institution that has survived two world wars, the Great Depression, and the collapse of the steel industry, which had built and once dominated the Pittsburgh region. The story of Kennywood is not about events that have changed the world but a simple place where people go to have fun and forget about their worries and cares, if only for a little while. It is about a place that has made so many people happy, including park employees (known as team members by park management). Their memories of the park remain vivid for most of their lives. Many of these people wish to share the same joyous memories with their families and friends, introducing yet another generation to the wonderful thrills, excitement, and nostalgia that can only be found at Kennywood. This book will try to recapture some of those feelings and memories that may have been forgotten with the use of nostalgic photographs and postcards. It is not, however, designed to be the definitive history of the park. Two outstanding books, *Kennywood: Roller Coaster Capital of the World* and *More Kennywood Memories*, both authored and expertly researched by Charles J. Jacques Jr., have the distinctive honors of being the most comprehensive books written on Kennywood. This book will be more of a nostalgic, photographic journal of this happy place. Hopefully, the pictures and captions will help bring some of your favorite Kennywood memories back to life. So, sit back, relax, and remember to keep your arms and legs inside the car at all times. Do not stand up while the ride is in motion! Our journey through Kennywood is about to begin.

One

THE END OF THE LINE

When people hear the statement "the end of the line," it usually means the end of the story for the subject involved. But for a traditional amusement park named Kennywood, located just 10 miles southeast of the city of Pittsburgh, Pennsylvania, the end of the line is where the story for the park begins. During the late part of the 19th century, privately owned electric trolley companies were building lines to all sections of major and minor cities throughout the nation. These businesses were like any other, and increasing profits was their goal. To help increase ridership on summer weekends, many trolley companies built small picnic parks at the end of their lines. Since electricity was already being generated and power lines were already supplied to the location, the addition of electric-powered amusement rides was relatively simple. Thus the creation of the "trolley park."

Kennywood's story starts out the same way. The Monongahela Street Railways Company, which was partly owned by famed Pittsburgh banker Andrew Mellon, wanted to create a beautiful picnic park at the end of their line in Mifflin Township. The location, part of a farm owned by Anthony Kenny, was already a favorite picnic spot for local residents. The scenic area, which sat on a bluff overlooking the Monongahela River valley, had been popular since about the time of the American Civil War, when it was known as Kenny's Grove. (The location was also the site of a historic event during the French and Indian War known as Braddock's Crossing. On July 9, 1755, British Maj. Gen. Edward Braddock was mortally wounded while his troops crossed the Monongahela River valley below. George Washington was a young colonel to Braddock and fought with him during the infamous battle, which ended in retreat for the British.)

When the area was leased from the Kenny family in 1898 to the Monongahela Street Railways Company, it was renamed Kennywood Park by Andrew Mellon. George S. Davidson, the company's chief engineer and the park's first manager, designed the park's original layout. A carousel, the Casino building, and a dance pavilion were added in 1899, and the start of Kennywood as a ride park was born. A bandstand was built in 1900, the Old Mill ride was added in 1901, and the park's first roller coaster was added in 1902. The park changed managerial hands after a few seasons as the trolley company no longer wanted to manage it. In 1906, the park's hired manager, Andrew S. McSwigan, along with Fredrick W. Henninger and A. F. Meghan, leased and operated the park under the name of Kennywood Park Limited. The park has been managed and operated by descendants of the Henninger and McSwigan families ever since. From the beginning of their partnership, they agreed that the park would be a clean, family friendly place that would forbid alcohol, gambling, and other less-than-desirable activities. They would also maintain the park with the utmost care, investing in new attractions every year, or so, to keep people wanting to come back. These philosophies are still in place today, which is why the park has survived, thrived, and prospered for more than 100 years.

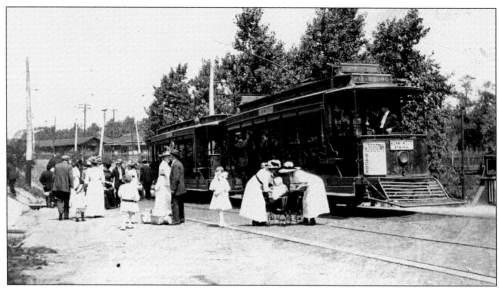

A trolley arrives at the end of the Monongahela Street Railway Company's line in 1898 to pick up and drop off riders at the entrance to their new picnic park, Kennywood Park. Dressed in the most formal of fashions, guests flocked to the beautiful grounds that were once known as Kenny's Grove. Located on a portion of Anthony Kenny's farmland in an area that would become known as West Mifflin, the park was built to help increase trolley ridership on the weekends.

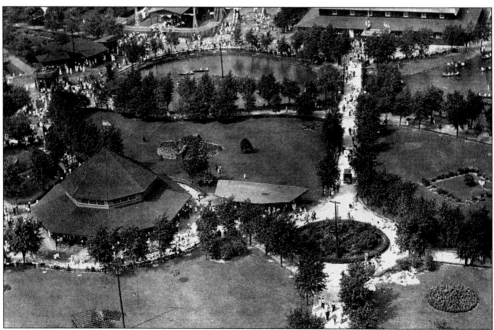

In this aerial photograph taken c. 1910, the layout designed by Monongahela Street Railways' engineer, George S. Davidson, is evident. Lush gardens surround the pathways leading to each area of the park. A central hub in the pathway leads guests to the various sections. The octagonal building on the left is the carousel structure. Directly across the bridge, over the lagoon, was the dance hall, with the original Racer coaster station to its left.

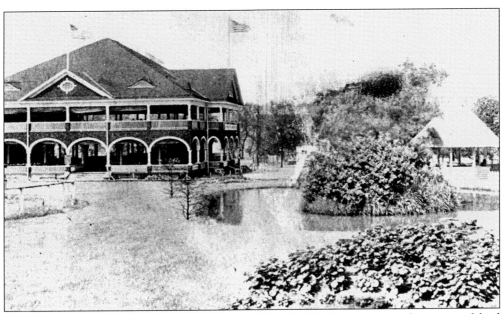

The open-air Casino restaurant was built in 1899 and offered patrons a wide variety of food items. It was particularly popular for guests who chose not to bring a picnic lunch and guests who chose to have a fully cooked meal instead. Today, the Casino building is an enclosed buffet restaurant and one of the original buildings still standing in the park.

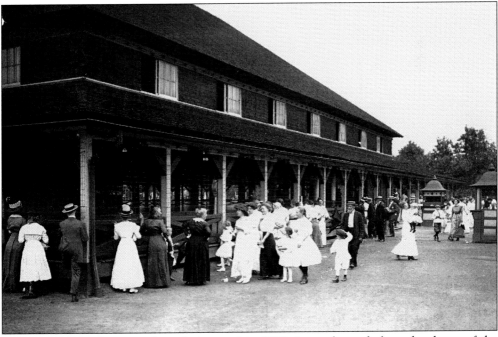

A large open-air dance pavilion also opened in 1899. It was located along the shores of the park's lagoon and was accessible via a small wooden footbridge or by a scenic walk around the lagoon. The dance hall, as its name suggests, provided dancing with live entertainment for more than 50 years until it was converted into a walk-through attraction in 1953. It later became two rides and eventually burned to the ground in 1975.

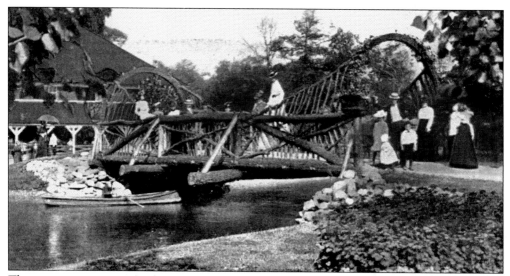

This rustic, yet ornate, footbridge connected the dance hall with the rest of the park. Notice how narrow the lagoon was at this point during the park's early years. The lagoon was enlarged in subsequent years, and a larger, more arched bridge was built to allow rowboats from the lagoon to pass underneath it. (David Hahner Collection.)

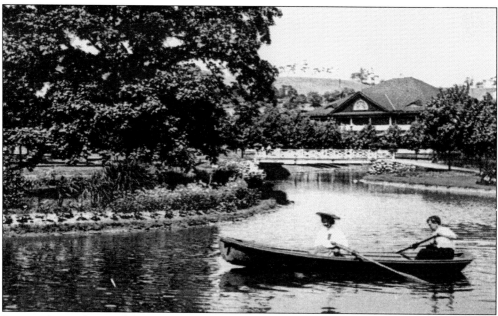

Renting a wooden rowboat on Kennywood's lagoon was a highlight at the park in 1898 and became a tradition that lasted for many decades. Rowers passed by immaculately manicured islands and shorelines. Starting in 1927, rowers could catch one of the circus acts on the Lagoon Stage if they were fortunate enough to rent their boat just before showtime. In later years, the wooden boats were replaced with aluminum ones and then eventually fiberglass paddleboats in 1982. (Jim Futrell Collection.)

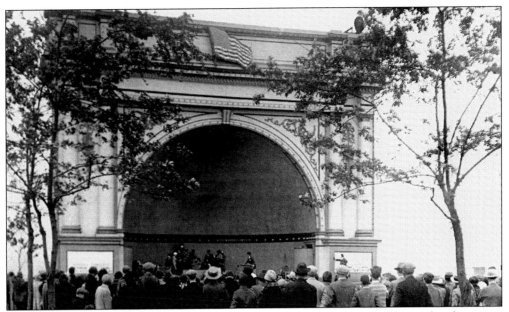

This beautiful arched bandstand was added to the park for the 1900 season. Free band concerts were performed here on a regular basis every summer during the early years. Other forms of entertainment also graced its stage during its 60 years of existence. Tragically, the bandstand burned to the ground on the park's opening day in April 1961. It was replaced with a newer, more modern amphitheater in 1962.

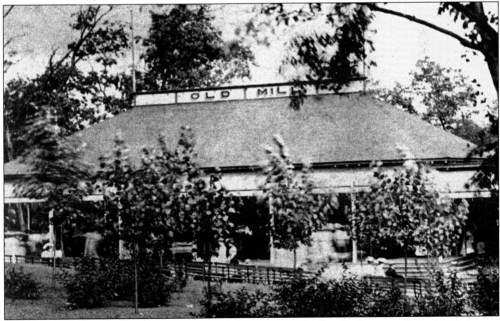

One of the earliest rides at Kennywood was the Old Mill, which opened in 1901. It was the park's first dark ride and consisted of small wooden boats following a narrow channel of water through a covered wooden structure. Along the route, passengers were enchanted with glimpses of "fantastic" and "grotesque," electrically lit scenes, according to an early park promotional brochure.

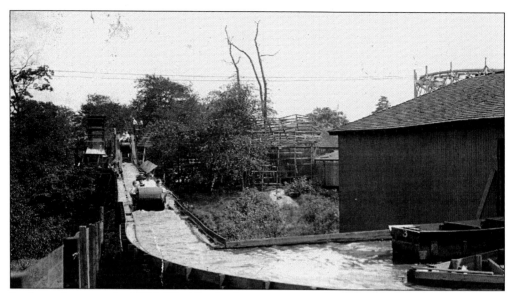

In the early years, the Old Mill offered riders a scenic trip both indoors and outdoors. After journeying through the ride's "gorgeous grottos and musical caves," the boats then voyaged outside the mill for a brief glimpse of the park. At the end of the ride was a small hill that the riders' boats would slide down for an exciting finale. Notice how the mill's waterwheel was located next to the chute during this period.

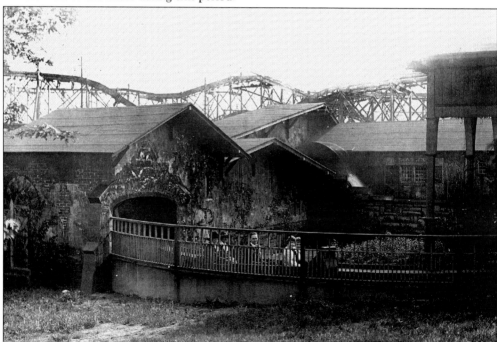

Even though the Old Mill has been renovated and re-themed many times over, it is still considered the oldest operating ride in the park. Its biggest renovation occurred in 1922, when the entire ride was rebuilt and enclosed, and the small chute finale was removed. The park's first roller coaster, the Gee Whiz Dip the Dips (originally called the Figure Eight Toboggan) can be seen behind the Old Mill's structure in this mid-1920s photograph.

This postcard from the park's early years features the Steeplechase Building, later called the Wonderland Building. This huge, classical-looking structure actually housed many attractions, including the park's first "pavilion of fun," or fun house. It was also home to an "Irish village" and served as the loading area for the Steeplechase ride from 1903 to 1904. The loading station for the Dip the Dips Scenic Railway coaster replaced the one for the Steeplechase in 1905. (Dick Bowker Collection.)

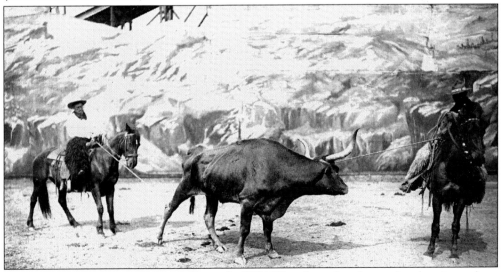

During the early 1900s, Kennywood hosted a Wild West show that featured authentic cowboys and cowgirls performing western-style stunts and acts on horseback for the crowds in the athletic field in front of the Dip the Dips Scenic Railway structure. In this photograph, two cowboys demonstrate the roping of a steer. A re-creation of a Native American village featuring real Indian tribes was also part of the popular show.

15

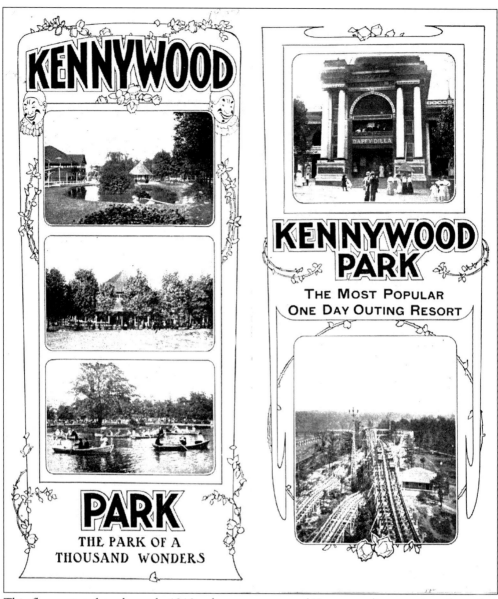

This flyer, printed in the early 1910s, showcases many of Kennywood's attractions from that time period. Photographs in the first column, from top to bottom, are the park's lagoon and Casino restaurant, the carousel building, and rowboats on the lagoon. The second column features the Daffy Dilla fun house and the original 1910 Racer roller coaster. As the brochure states, Kennywood Park was considered "The Most Popular One Day Outing Resort" and "The Park of a Thousand Wonders."

Two

FLOWERS, TREES, AND NEON

Even before Kennywood was founded, people had come from all over the region to enjoy the natural wooded beauty that was Kenny's Grove. Later, when the Monongahela Street Railways Company developed the park, the company made sure to include beautiful gardens and landscaping as part of the charm that would be Kennywood. Over the years, park management has prided itself on the many floral gardens and well-manicured, tree-filled grounds that the park has offered for more than a century. Even today, Kennywood's beauty comes from not only the plentiful gardens but also the numerous tall trees that provide much-needed shade on those hot and muggy Pennsylvania summer days. Although the land surrounding the park has become a heavily populated and developed suburban and industrial area, Kennywood remains a pleasant oasis amid the ever-increasing urban sprawl.

Equally important to the park's natural beauty is the upkeep and cleanliness of the park's midways, buildings, and rides. Since the beginning, park management has tried to make sure everything looks fresh, clean, and presentable so guests will want to return time and again. Just about everything gets a fresh coat of paint every spring, from the trash cans and park benches to the building facades and roller coaster structures. The architecture of the park can range from quaint and nostalgic to bold and gaudy; where else in the world can you find such harmonious coexistence of such diverse styles than at a traditional amusement park like Kennywood?

Yet, as wonderful in imagery as Kennywood is during the day, it becomes even more magical at night, when all of the park's lights transform the amusement center into a luminescent wonderland. Colorful neon lights outline many of the buildings and signs throughout the park, some even offer wonderfully animated images. It was electricity that built and still runs this park, and this is never more evident than when all of the magnificent lighting is turned on in the evening. Electric light was a novelty at the turn of the 20th century; today it is commonplace and essential for western civilization. At Kennywood, it is pure magic!

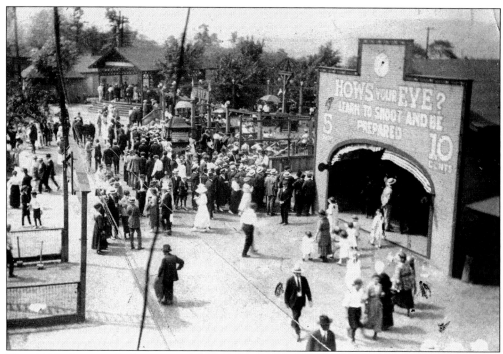

This 1919 photograph shows one of the park's early midways. The shooting gallery building proclaims "How's Your Eye? Learn to Shoot and Be Prepared" in reference to America's recent involvement in World War I. Just beyond is the original 12-car Whip ride installed that year. It was replaced with a 16-car model in the same location in 1927 that was installed in an open-air arched structure. Across the midway was the ever-popular High Striker game, where men tested their strength with a sledgehammer and tried to ring the bell.

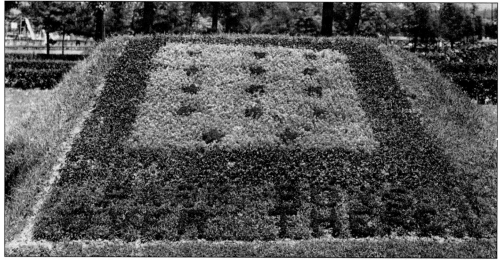

In 1916, a beautiful floral calendar was added to the plentiful gardens in the park. The date was changed daily during the summer season. However, during America's involvement in World War I in 1917 and 1918, the calendar was converted into a tribute to the "park boys over there." Many of Kennywood's seasonal workers had been drafted and sent to fight in the battlefields of Europe during the war.

Kennywood received its first Caterpillar ride in 1923. Traver Engineering of Beaver Falls, Pennsylvania, built this original version of the popular amusement ride. The circular track featured undulating hills with a canvas canopy that covered the vehicles while in motion. The ride was installed near the lagoon, approximately where the Paratrooper ride and the 1927 Dentzel Carousel sit today. Notice the plentiful gardens and trees in the park-like setting. Beyond the ride is the Casino restaurant, and in the distance is the band shell. (David Hahner Collection.)

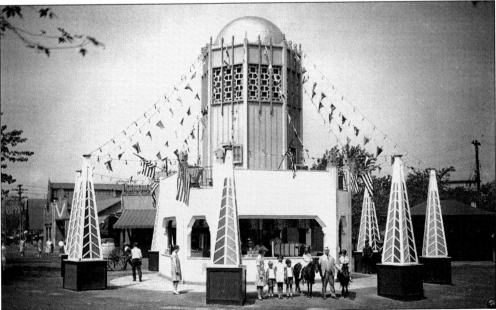

The fanciful Tower refreshment stand was built in 1929. Located within the second story of the structure was the studio for "the Voice of Kennywood," the park's public address and musical entertainment system that was revolutionary for its time. The addition of the Tower was the park's answer to the competition of radio, which was proliferating throughout the country during that period. Even today, whenever announcements are made within the park, "This is the Voice of Kennywood," is always the first phrase spoken.

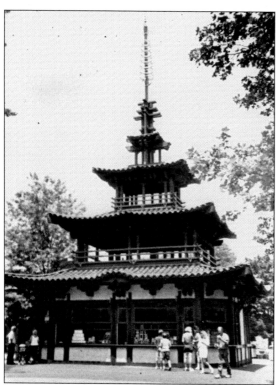

The Tower refreshment stand was redecorated into a modern abstract art form in the late 1960s. It no longer housed the studios for the Voice of Kennywood, which had been moved to the Starvue Plaza stage and was later moved to the park offices. In 1986, the building was razed and replaced with an Asian pagoda. Inspired by a similar structure in Tivoli Gardens, Copenhagen, Denmark, the exterior was decorated with hand-carved dragon heads that once adorned the Old Mill's boats.

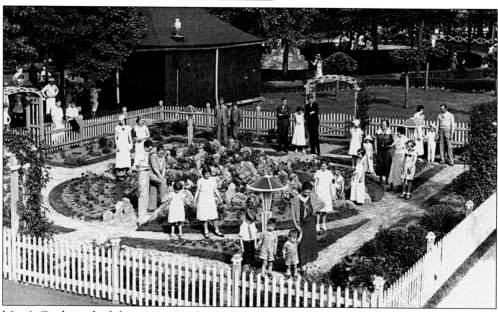

Mary's Garden, which became a popular garden retreat in the park, was added in 1929 between the Casino restaurant and the parking lot, on the site of the park's first pony track and later the miniature railroad. The name was derived from the familiar nursery rhyme "Mary, Mary, Quite Contrary." It remained a popular spot for taking photographs for more than 30 years until it was converted into an Oriental garden in 1967. A remnant of the garden still exists today located next to the park's main office building.

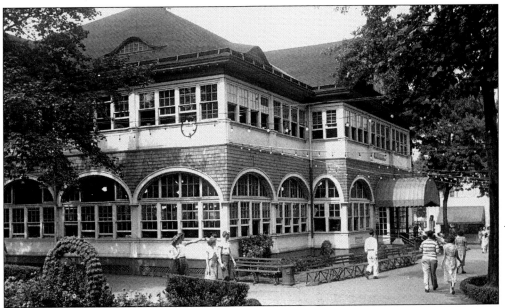

The Casino restaurant was completely enclosed in 1946 and continued to provide waitress service. By the 1970s, a new patio was added to the front and side of the building to offer outdoor seating. Cafeteria service was then offered in conjunction with sit-down service but later replaced waitress service during the 1980s. The restaurant has had many names over the years, including the Patio and Parkside Terrace, which it is still called today. In 1983, the Pittsburgh History and Landmarks Foundation proclaimed the building a regional historic landmark.

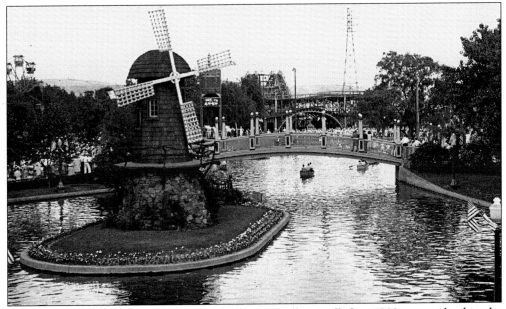

The majestic ornamental Dutch windmill was originally installed in 1928 on an island in the park's lagoon where the Rockets circle swing was later added in 1940. That same year, the windmill was moved across from the Old Mill and next to the Lady's Cottage rest rooms, where it has greeted guests at Kennywood's tunnel entrance ever since.

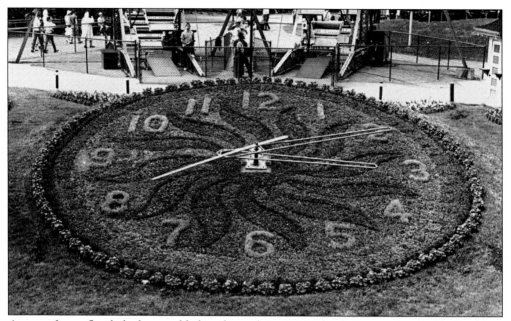

A magnificent floral clock was added to the park in 1953. The design on the clock's floral face changed every year, usually representing some basic theme for the park for that season. Some designs featured include the Liberty Bell for the nation's bicentennial in 1976, a locomotive representing the park's train ride, Kenny Kangaroo, and a carousel horse. The detail of each year's design showcases the wonderful talents of the park's gardening staff.

Leo the Paper-Eating Lion was a fun new way to help control litter in the park when it was introduced in 1964. The fanciful circus wagon featured a friendly looking lion that sucked trash from a child's hand via a strong vacuum. Leo would "speak" to the children via a recording to reassure them that he was only a paper-eating lion. The talking trash receptacle was originally located on the midway near the Tower refreshment stand. It was moved to Kiddieland in later years. Leo was retired after the 2002 season.

Those who have visited Kennywood may remember having their picture taken while swapping yarns with Cowboy Joe. This fiberglass figure was purchased in 1960 and has been a popular photograph opportunity in the park ever since. Although Joe and his bench have been positioned several places throughout the park, they are best remembered near the fountain by the train station. Today, Joe can be found sitting across from the Old Mill's new incarnation, Garfield's Nightmare.

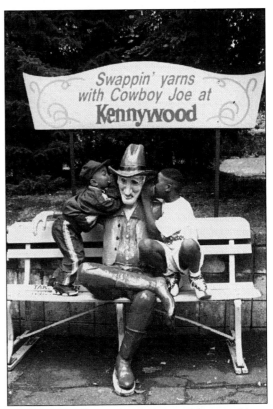

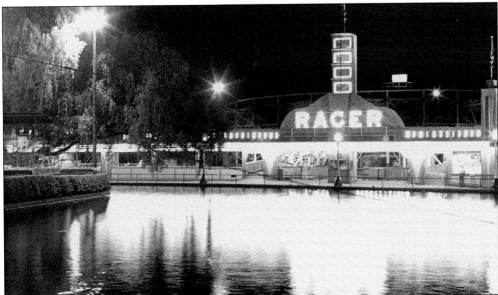

This wonderful night shot showcases the new world's fair–style facade that the Racer received in 1946. Its ultramodern appearance helped to give the 1927-built ride a fresh look. As technology advanced, lighting increasingly became an important feature to attract riders at night. Since pay-one-price admissions were not introduced until the 1970s, rides still individually made profits via ticket sales. A flashy new entrance often helped bolster ridership.

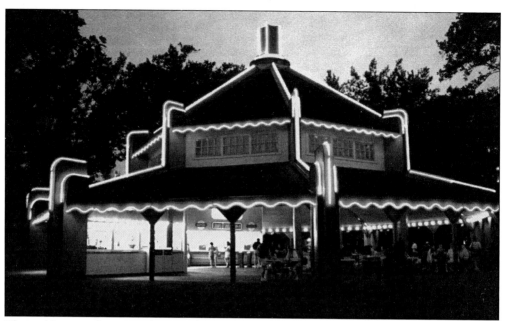

The park's original octagonal carousel structure was converted into a refreshment stand in 1927, when it became known as the soda fountain. During the late 1940s, the building's exterior was redone with an Art Deco flair, outlined in colorful neon lighting. The refreshment area was converted into a small food court in 1992 and renamed, appropriately, Carousel Court. The fanciful neon-covered exterior was retained and remains a brilliant reminder of how many of the park's buildings were covered in colorful neon during the 1950s and 1960s.

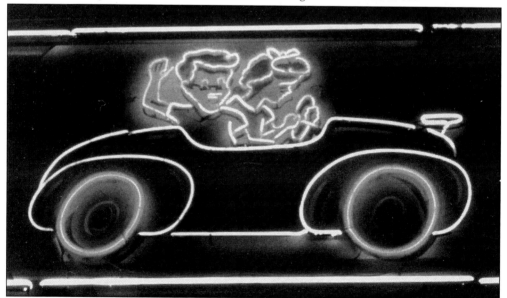

Like most of the ride structures and buildings in the park, the signage above the loading area of the Auto Race (then called the Auto Ride) received a neon makeover during the 1950s. The redesigned front featured an animated racecar with children riding, and the neon lighting simulated motion in the car's wheels. During a recent renovation of the ride front, the vividly animated automobile was preserved, helping Kennywood retain its magical nighttime charm.

Three

PICNICS AND ENTERTAINMENT: KENNYWOOD TRADITIONS

Picnicking at Kennywood has been a longstanding tradition that predates the park itself. Local residents traveled to Anthony Kenny's farm in what was then Mifflin Township in the mid-1800s. The area became popular with picnickers for its scenic, wooded beauty and its overlook of the Monongahela River; it became known as Kenny's Grove. After the Monongahela Street Railways Company created Kennywood in 1898, picnicking continued to be a main draw for the park. To increase attendance, other activities and diversions were added. Of course, amusement rides became the major draw for the park and eventually dominated its course. However, subtler, yet no less important, features were included as well. A band shell was built in 1900 to offer summer band concerts for the throngs of attendees to the park. Nationality heritage days also began that year. Diverse ethnic groups gathered and celebrated with traditional song, dance, food, and other cultural activities from their native lands. This has become one of Kennywood's longest-standing traditions.

In 1927, a stage was built on a small island in the middle of the park's lagoon where circus acts would perform daily. The acts were free to park goers, which proved to be an invaluable lure in bringing patrons to the park, especially during the lean years of the Great Depression and World War II. This tradition continued until 1994, when a new thrill attraction, the Skycoaster, displaced the once-popular circus acts from the Lagoon Stage. The acts were moved to the side of the lagoon in front of the Wonder Wheel in 1994 and lasted only one more season, when they were finally retired.

Company picnics have been a longstanding source of revenue for the park and continue to be the backbone of its group sales efforts. Another longtime Kennywood tradition started in the early years, when the park offered school picnics. These annual outings helped keep attendance up during the Great Depression and remain a popular event for school children in Pittsburgh today. Kennywood started another entertainment tradition in 1950 with the "Fall Fantasy Parade and Festival of Music," which occurs in the last two weeks of August to help boost attendance during the end of the season. The parade remains a popular spectacle, featuring fanciful themed floats and regional high school marching bands.

The park's costumed character mascot, Kenny Kangaroo, made his debut in 1974, greeting guests and posing for photograph opportunities with enthusiastic youngsters. Comic-strip character Garfield, and his pal Odie, joined Kenny as official park mascots in 2000. Picnics and entertainment are as important to the park as its rides, proving that Kennywood offers something for everyone.

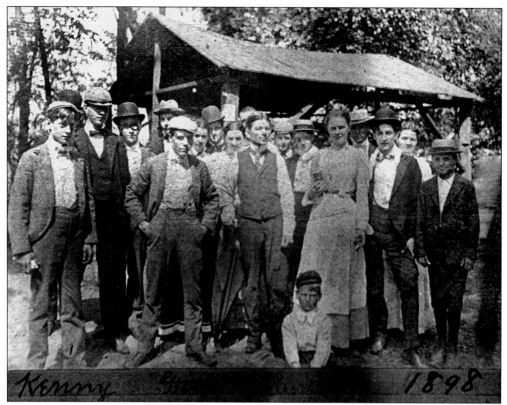

Long before Kennywood, picnickers gathered on a wooded site overlooking the Monongahela River on Anthony Kenny's farmland in Mifflin Township. The site became known as Kenny's Grove and was popular since the time of the Civil War. This photograph, taken in 1898, is possibly one of the first pictures taken at the newly formed Kennywood. The group posed in front of one of the first picnic shelters built at the park.

An athletic field was added in 1900 and included a baseball diamond, as well as a large grassy area for other activities. It featured a large grandstand for spectators to watch the daily baseball games and other sporting events. The athletic competitions were moved to a field across the road to make way for the new swimming pool, which opened in 1925. The newer field was slowly converted into a parking lot, as the use of automobiles increased, and it eventually disappeared altogether in the late 1960s.

School picnic outings were one of the earliest forms of group ticket sales to attract patrons to the park. During the Depression, school picnics helped keep the park financially afloat. Attendance at school picnics was soft but steady during those lean years. After the Depression, the Kennywood School Picnic Day became the highlight of the school year for many children in the region. Today, the school picnics, which occur during the months of May and June, continue to be one of the park's most popular traditions.

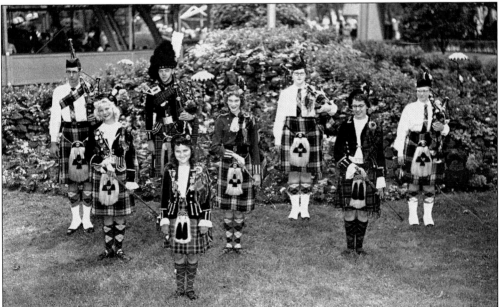

In 1900, Scottish clans began using the athletic field for their picnics and tournaments, starting the nationality-day tradition that expanded and continued for many different ethnic groups throughout the region. In this 1960 photograph, a Scottish bagpipe regiment poses in a garden next to the carousel.

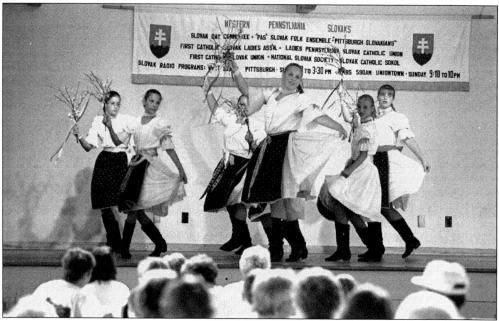

Although the traditional Scottish Day picnic ended in 1975, other ethnic groups, such as Croatian, Hungarian, and Italian, still converge on the park one day every summer to celebrate their heritage with food, festival, and song. Italian Day continues to be the park's biggest ethnic event of the season, but other groups, such as these dancers performing on Slovak Day in 1999, are no less important in showcasing Pittsburgh's rich cultural diversity.

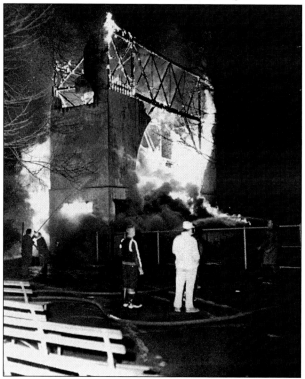

Tragically, the park's historic 1900 band shell, which provided free entertainment for park visitors for more than 60 years, burned to the ground after the park closed on opening day April 24, 1961. An electrical problem with the neon lighting that was added to its facade was to blame. Thankfully, no one was injured during the blaze, and quick-thinking firefighters doused the nearby Pippin roller coaster to prevent it from being lost as well. The Pippin was back in service shortly afterwards.

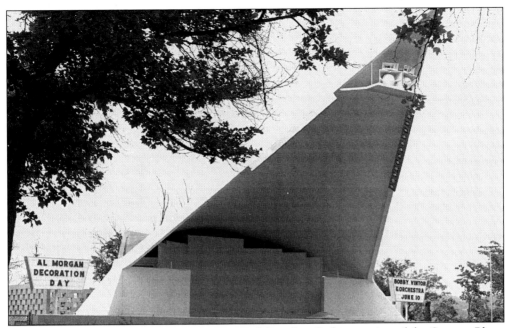

One year later, in 1962, a new concert venue debuted with the opening of the Starvue Plaza. The new stage featured an ultramodern triangular design and continued to allow the park to offer free concerts and shows to park goers, mainly on weekends. The stage continued to host shows and special performances until it was removed in 1984 to make way for the Raging Rapids water ride.

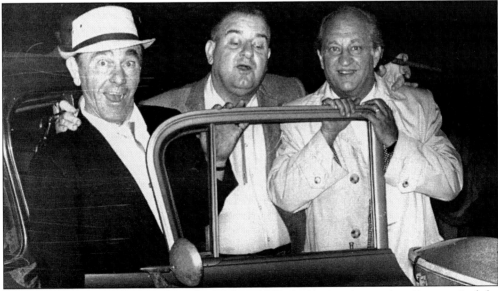

Television in the mid-1950s through the late 1960s became a new entertainment rival for Kennywood, as more people stayed home to watch the newest electronic marvel. To fight fire with fire, Kennywood management brought television and film celebrities to perform on the Starvue Plaza stage. Here, the Three Stooges, Moe Howard, "Curly" Joe DeRita, and Larry Fine, make an appearance at Kennywood in the early 1960s. The Three Stooges were usually a huge hit at the park.

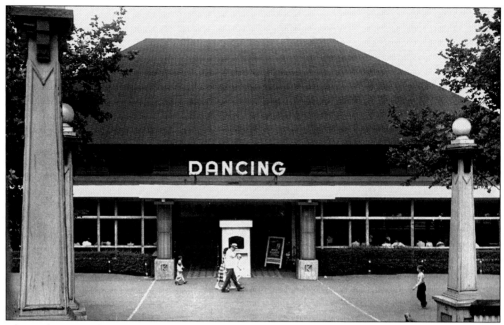

The park's 1899 dance hall also offered live entertainment. Top bands and popular orchestras entertained thousands of guests who came to dance at Kennywood every summer until 1953, when the dance hall closed. It was enclosed in 1934 to offer winter roller-skating, another effort to increase cash flow year-round during the Depression, but skating was soon discontinued for lack of popularity.

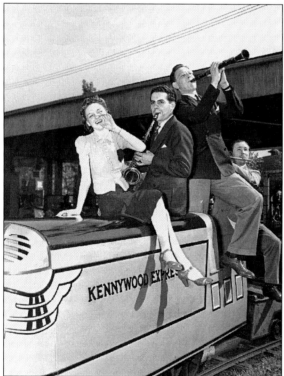

The dance hall was host to many famous bands throughout the years, such as Ozzie Nelson, Benny Goodman, Rudy Valee, and even Lawrence Welk. In fact, the appeal of seeing such performers live was a major factor in Kennywood's survival during the Great Depression. In this photograph, entertainer Tommy Carlyn and his orchestra pose for a publicity still on the park's train in 1939.

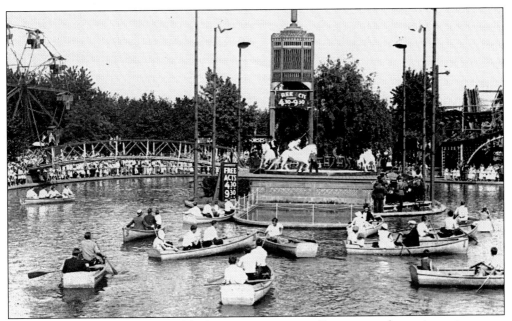

One of the park's most memorable free entertainment offerings was the various circus acts that were performed on the island stage, which was built in the middle of the park's lagoon and debuted in 1927. Twice daily at 4:30 p.m. and 9:30 p.m., the "Big Show," as the Voice of Kennywood referred to it over the park's public address system, drew enormous crowds along the edge of the lagoon. Those lucky enough to be able to rent a boat at showtime often got the best view.

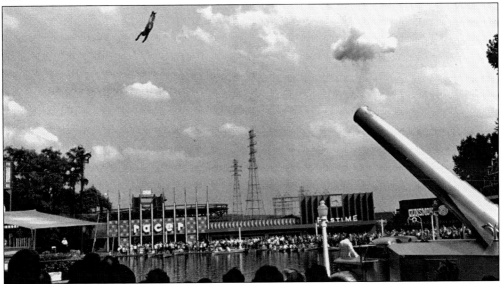

One of the most popular and easily the loudest acts to perform on the Lagoon Stage at Kennywood was the human cannonball. The performer was literally shot from a large cannon on one side of the lagoon to a net on the front of the stage. Although the act only lasted a few seconds, it nevertheless pleased the huge crowds that lined the lagoon's shoreline. The circus acts remained a popular attraction at the park until they were replaced by the Skycoaster thrill attraction in 1994.

In 1950, a new tradition was introduced when the first Fall Fantasy and Festival of Music Parade was held in the park. The parade was created to help boost sagging attendance in the latter part of the season, at the end of August. Fanciful floats were built to match the particular year's theme, and high school marching bands from around the region performed.

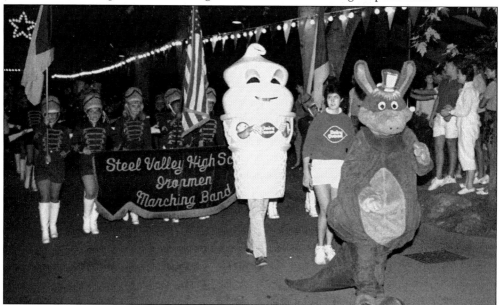

Local high school bands have performed during the parade since its inception in 1950. Park mascot, Kenny Kangaroo, who was introduced in 1974, is often seen leading the pageant each night during its two-week run at the end of August. Band members usually love to march at Kennywood, which helps to signify the end of summer and the start of a new school year. (Photograph by David Hahner.)

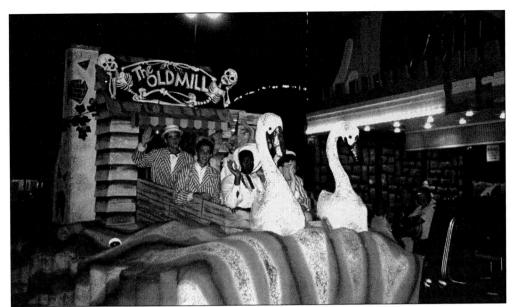

In 1998, Kennywood celebrated its centennial with a special Fall Fantasy parade with each float representing a significant ride or event that occurred during the park's 100 years. Here, the park's oldest ride, the Old Mill, is represented in a float, which is passing by the Le Cachot dark ride. The Fall Fantasy parade continues to be a huge end-season draw for the park. (Photograph by David Hahner.)

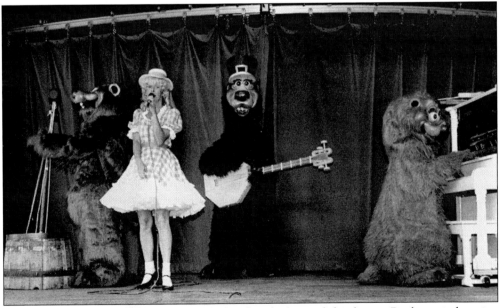

In 1979, the Garden Stage was built under the platform of the former Rockets circle-swing ride, which was removed after the 1978 season. This portion of the lagoon was filled in, and a new picturesque central stage area was created. During the debut season, the stage featured the Razmataz singing and dancing group as well as the Goldilocks and the Three Bears show, which offered a comical country-music act. Today, the Garden Stage is the main entertainment venue in the park.

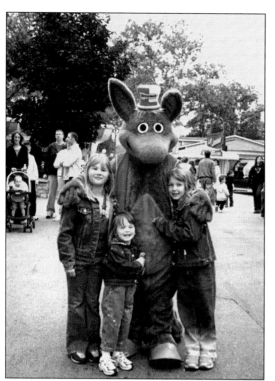

The park's official mascot, Kenny Kangaroo, made his debut in 1974. The lovable costumed character is seen walking throughout the park daily, giving hugs, posing for photographs, and even sometimes taking in one of the many rides of the park. He is often the park's ambassador to various communities outside of the park in the Pittsburgh region, where he will sometimes make guest appearances to events, such as parades and festivals. Other park-exclusive characters, Colonel Bimbo, Jeeters, Yellow Bird, and Blue Monster, joined Kenny a few years later. (Photograph by Thomas Hahner.)

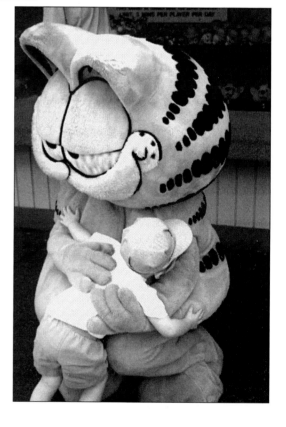

In 2000, Kennywood acquired the rights for use of the popular comic-strip characters Garfield and his pal Odie in the park. Both lovable characters join Kenny Kangaroo in greeting children and offering photograph and hugging opportunities. Their likenesses can also be found in Kiddieland and in the newest re-theming of the park's Old Mill ride, Garfield's Nightmare. (Photograph by David Hahner.)

Four

RIDING THE PAINTED PONIES

Historically, the carousel is one of the earliest forms of amusement rides. No matter its age, a carousel remains an essential centerpiece for any good amusement, or theme, park. With its wondrous band organ playing melodious tunes to the delight of riders, the carousel itself becomes a beautiful, gigantic music box that gives a nostalgic tranquility to the park. No screams of fear are heard here, only the sounds of laughter and the upbeat tempo of the essential band organ.

Kennywood has been home to three different carousels since its first was installed in 1899. Gustav Dentzel of Philadelphia built the first carousel for the park. It was a stationary, non-jumping, menagerie model, which featured many hand-carved animals along with the customary horses. It was installed in a large, octagonal, wooden structure near the center of the park. In 1913, this carousel was traded in for a newer, all-jumping model that was built by T. M. Harton of Pittsburgh. The purchase of this newer carousel was ironic as Harton was Kennywood's main competitor for the region. He was owner of another large regional amusement park, West View Park, just north of Pittsburgh. In later years, Kennywood and West View would become large rivals for the amusement market share in the Pittsburgh area.

However, in 1927, Kennywood installed its third, and still current, carousel. Built by Gustav Dentzel's son, William, the new merry-go-round was originally built for use during Philadelphia's sesquicentennial celebration in 1926. It was never completed in time for that event, thereby allowing Kennywood to purchase it in time for the 1927 season. The park's previous two carousels were three-row models and were able to fit within the original 1899 carousel structure. The new Dentzel carousel was a much larger, four-row design. A brand new pavilion was erected closer to the park's lagoon to house it. The original building became a refreshment stand, which still exists.

Today, the Grand Carousel is the most famous and longest-lasting carousel in the park. It has become the object of many fond memories, as well as the subject of numerous works of art by various local artists. It was completely restored to its majestic state in 1976, in time for the nation's bicentennial celebration and its own 50th anniversary one year later, when it was designated a historic landmark. This beautiful park centerpiece still beckons riders with its antique Wurlitzer band organ, thousands of glistening lights, and wondrous 72 hand-crafted horses, lion, tiger, and two chariots that just beg to be explored and ridden upon. The carousel has truly embodied the spirit of Kennywood, bringing joy and laughter to generations of children, and to carousel and amusement park lovers of all ages.

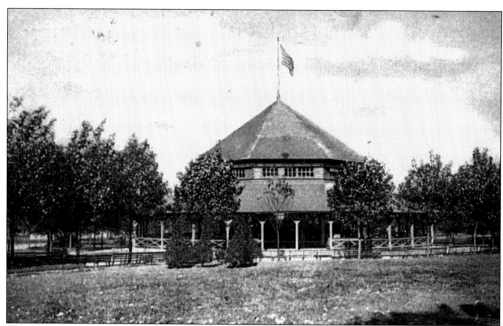

Seen here is the park's original carousel building just a few years after it was built in 1899. It was home to two wonderful merry-go-rounds for 27 years. When the park purchased the William Dentzel–built machine for the 1927 season, a new pavilion had to be constructed to house the larger ride. The older building was then converted into a soda fountain food stand. Today, the building is still used as a refreshment stand, renamed Carousel Court. (Dick Bowker Collection.)

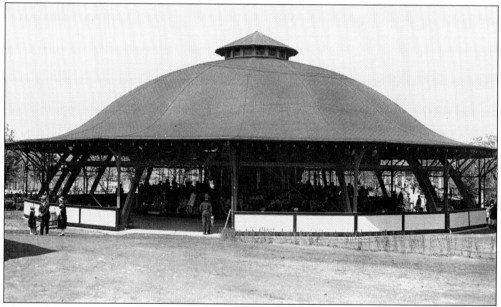

The park's newest carousel building was built in 1927 to house the larger William Dentzel machine. It is located almost adjacent to the original pavilion, closer to Kennywood's central lagoon. The structure was made large enough to allow visitors to watch the gorgeous machine in motion and also to provide some shelter from the sun and rain.

During the 1930s, the carousel proved to be a popular attraction, even during the height of the Great Depression. Repeat rides were usually allowed if you had your tickets ready for the ride attendants who circled the ride during each cycle. This repeat-ride tradition ended during the mid-1990s, when an ornate protective hand railing was added, encircling the ride for guest safety. Tickets are now collected as patrons enter the ride area.

Children of all ages have adored this beautiful carousel since its opening in 1927. Some of the carousel's horses have been given names and been part of stories over the years as well. These two young lads from the 1940s are aboard Pegasus, the lead horse of the carousel. According to legend, his spirit calls to the children to ride upon him and to all the other horses that he leads around the carousel.

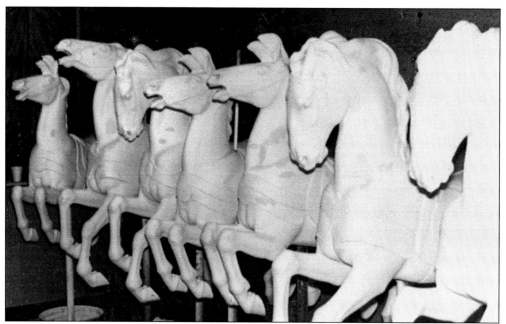

In the park's off-season of 1975–1976, the carousel underwent a complete restoration. Decades worth of paint was stripped from each horse to reveal the hand-sculpted beauty of each figure. Countless hours were spent during that off-season to make sure each figure was ready for opening day in April 1976.

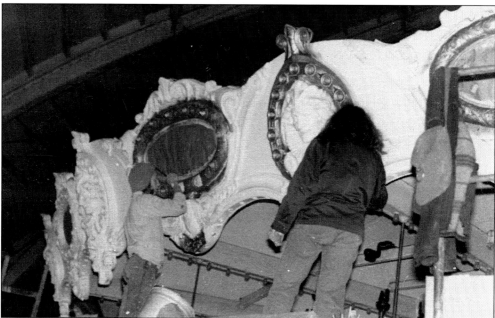

Each horse, as well as the lion, tiger, chariots, jester heads, and canopy molding, were restored by hand. Art students from Carnegie Mellon University assisted Kennywood's talented carpenters, craftsmen, and maintenance personnel in the painstaking process. To meet the opening-day deadline, restoration work began the day after the park had closed for the season, Labor Day, 1975.

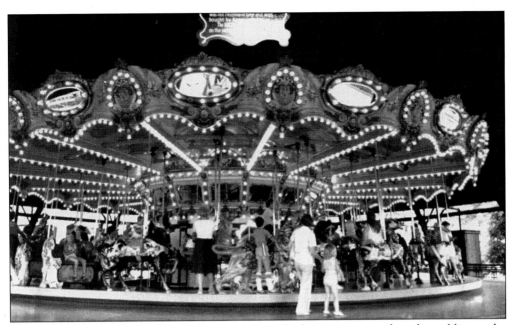

The newly restored Grand Carousel, as it came to be known, reopened to the public on the park's opening day in April 1976, in time for the nation's bicentennial celebration. One year later, for its 50th anniversary, the carousel was designated a historic landmark by the Pittsburgh History and Landmarks Foundation.

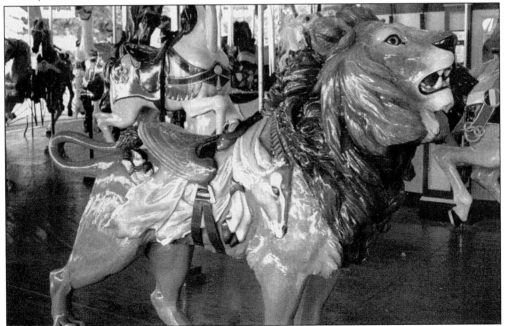

The meticulous attention to detail on Dentzel's figures is amazing. Note the shear realistic beauty of the lion, complete with a gazelle skin draped over its back as part of the saddle. All of the other figures on the outside row received equally extensive detailing as the lion, whereas the inner jumping horses, though not quite as detailed, still look remarkably realistic. (Photograph by David Hahner.)

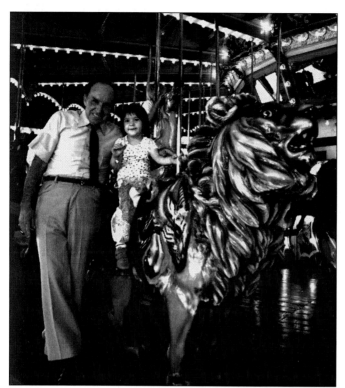

A familiar figure for many years at Kennywood was Tony Sacramento. He had been associated with the park's carousel since 1946 as manager of the historic attraction. His smiling face and warm greetings to the riders were a summer institution for nearly 50 years until his retirement due to poor health. Over the years, Tony was nicknamed "Mr. Kennywood" by many of his fans and co-workers alike. After his death in December 1998, Tony's funeral procession reverently drove through the park by the carousel in a fitting final tribute.

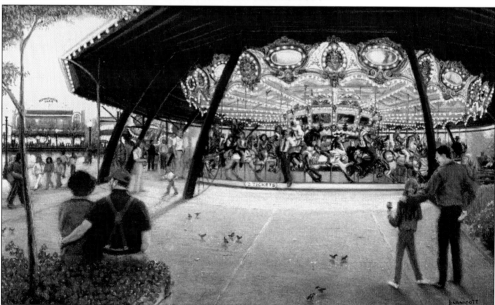

Kennywood's Grand Carousel has also been the inspiration of artwork for many local artists. Famed Pittsburgh scenic artist Linda Barnicott created this beautiful pastel work entitled *Ride With Me on the Carousel*. Linda's works are famous for incorporating people she knows into the scene. For example, standing on the carousel's platform is Tony Sacramento. She subsequently has created other scenic prints of the park, as well as four individual prints of the lion, tiger, and two horses from the carousel. (Linda Barnicott Publishing Company.)

Five

THE SCREAM MAKERS: ROLLER COASTERS

During the 1970s and 1980s, Kennywood billed itself as "the Roller Coaster Capital of the World." And rightfully so. It was during this period that Kennywood's existing roller coasters began to receive recognition for their excellence in design and thrills. In particular, the Thunderbolt wooden coaster was proclaimed "the King of the Coasters" in a 1974 *New York Times* article. Roller coaster historian Robert Cartmell searched the continent looking for the best coaster experience, and created a top ten list with Thunderbolt named as his very favorite. While newer regional theme parks were just rediscovering the drawing power of the roller coaster, Kennywood was already home to four wooden thrill-making treasures. Enthusiasts from all over the country and around the world discovered what almost every Pittsburgh-area thrill seeker had already known: Kennywood had great roller coasters! The fledgling American Coaster Enthusiasts held their third annual convention at the park in June 1980, which further solidified Kennywood's claim as the "Coaster Capital" when hundreds of coaster fanatics from across North America descended on the park.

However, Kennywood's coaster roots did not begin during this period. In fact, they began almost at the beginning of the park's existence with the addition of the Figure Eight Toboggan, the park's first coaster, in 1902. Modest by today's standards, the Figure Eight stood only about 30 feet high and went a thrilling, by 1902 standards, 8–10 miles per hour. It was located to the right of the Old Mill near the road and trolley line, where the Turnpike ride stands today. Built by Fred Ingersoll, a Pittsburgh native, it utilized a side-friction, or side-rail, track system, which kept the cars on the track. It was renamed the Gee Whiz Dip the Dips in 1906. Today, the only remaining example of this type of coaster in North America is Leap the Dips at Lakemont Park in Altoona, Pennsylvania.

Other side-friction coasters were added in these early years, but it was in the 1920s when Kennywood added three high-speed thrill rides that featured *under*-friction wheels, which forever shaped the course of the park. This new system allowed for faster, more-daring designs because it ensured the trains remained attached to the track at all times. The additions of Jack Rabbit, Pippin, and Racer became staples of Kennywood thrills for generations. In 1968, the transformation of the Pippin into the Thunderbolt led the way for Kennywood's coaster renaissance. The addition of modern steel coasters, such as Laser Loop, Steel Phantom, Exterminator, and eventually Phantom's Revenge, continued Kennywood's commitment to ride quality. Though other theme parks may offer more coasters than Kennywood will ever be able to install, the importance of quality versus quantity is even more evident today since Kennywood is still considered one of America's best roller coaster parks by many enthusiasts worldwide.

In this early photograph of the park, four young ladies are ascending the lift hill of the park's first coaster, the Figure Eight Toboggan, which was built in 1902 by Pittsburgh native Fred Ingersoll. It utilized a side-friction, or side-rail, track system, which kept the cars on the track. The ride was renamed Gee Whiz Dip the Dips in 1906 and removed after the 1921 season, after the opening of the park's Jack Rabbit roller coaster.

In 1903, the park added a Steeplechase ride, which was a different type of coaster in which patrons rode on wooden horses along a mildly graded coaster-type track. The half-mile-long course consisted of six separate tracks that ran side by side, creating the illusion of a horse race. This same type of ride was the centerpiece attraction at George Tilyou's Steeplechase Park on Coney Island in New York. Unfortunately, the ride was not as popular in Pittsburgh as it was in New York and only operated for two seasons. It was removed at the end of the 1904 season.

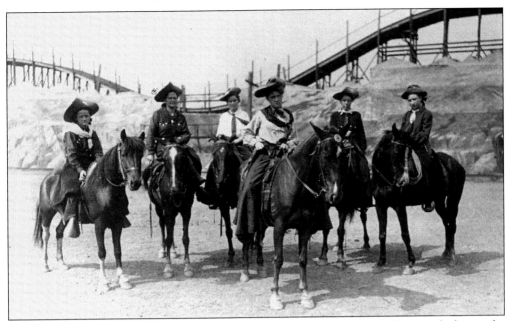

For the 1905 season, the Scenic Railway side-friction coaster replaced the Steeplechase ride. It was a long out-and-back design that ran along the edge of Braddock Road (now known as Kennywood Boulevard) and was visible from the trolley line that ran to the park. As seen in this vintage photograph, the structure served as a backdrop for the Wild West show that was a featured attraction at the park during the early years. The ride was also known as Dip the Dips.

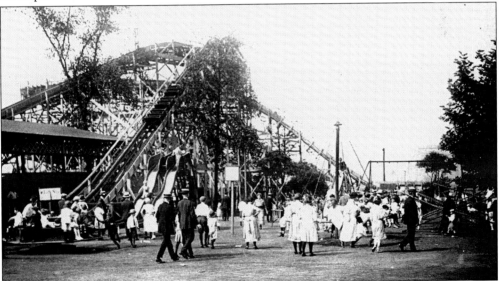

The park's original Racer coaster was added in 1910. It was built by the Ingersoll Brothers of Pittsburgh, who also built the park's Figure Eight Toboggan coaster. John A. Miller, who later became a legendary designer of wooden roller coasters in his own right, designed the twin-tracked racing layout. In the foreground is a children's playground that became a full-fledged "kiddieland" of children's rides in 1927, after the Racer had closed at the end of the 1926 season. The pony track temporarily filled this area from 1925 to 1926.

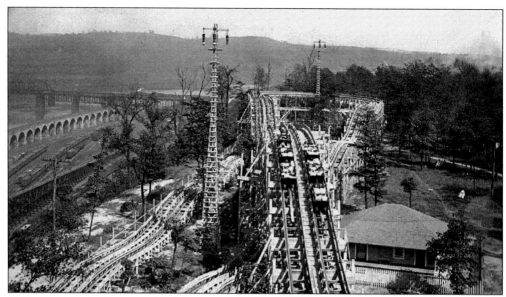

This magnificent photograph of the park's first Racer coaster, as seen from the top of the lift hill, shows the out-and-back layout of the ride, which was designed by John Miller. The twin tracks ran along the bluff overlooking the Monongahela River, offering riders a fantastic view of the valley below during the course of the ride. This was the first of many coasters that John Miller designed for Kennywood. The miniature train, Auto Race, part of Kiddieland, and some picnic shelters occupy this location today.

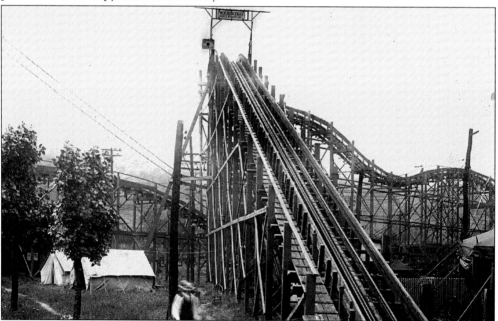

In 1911, the Speed-O-Plane coaster replaced the aging and more gentle Dip the Dips Scenic Railway along Braddock Road. The ride was much taller and faster than the scenic railway. It showcased more speed and modern-coaster thrills than any of its predecessors at the park, even though it was also a side-friction roller coaster. According to an old park advertising brochure, it cost $30,000 to build.

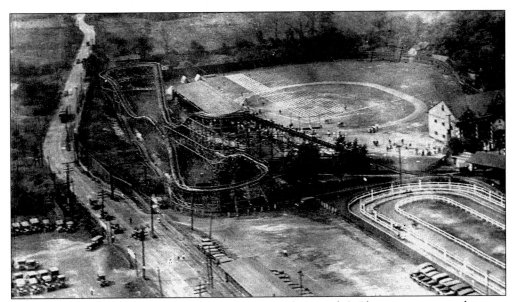

This aerial photograph from 1911 shows the layout of the Speed-O-Plane in its inaugural season. The athletic field is surrounded on two sides by the coaster, and the park's pony track is featured in the foreground. The ride was the last side-friction coaster to be added to Kennywood. It was removed from the park in 1923 and eventually replaced by the swimming pool a few years later. Today, this area is the location of the Lost Kennywood section of the park.

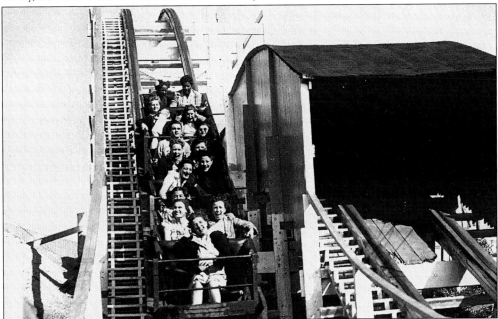

A landmark year in the world of coasters for Kennywood was 1920. Designer John A. Miller returned to the park—along with his partner, Harry C. Baker—to create Kennywood's first truly high-speed coaster, the Jack Rabbit. Utilizing a natural gully in the park, the Jack Rabbit was the first coaster built in the park to use under-friction wheels. This new design literally kept the train attached to the track with wheels both above and beneath the track. This system was patented by John Miller and is still in use with most wooden roller coasters today.

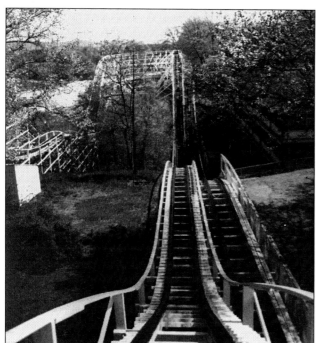

What makes the Jack Rabbit so unique and continuously popular, even to this day, is the 70-foot-high double dip that occurs as the ride's third major drop and first after the ride's lift hill. The "air time," or feeling of weightlessness, on the Jack Rabbit is one of the best of its type ever created. The ride's signature and world-famous double dip would not have been possible if not for John Miller's revolutionary under-friction wheel design, which modern wooden coasters use to this day.

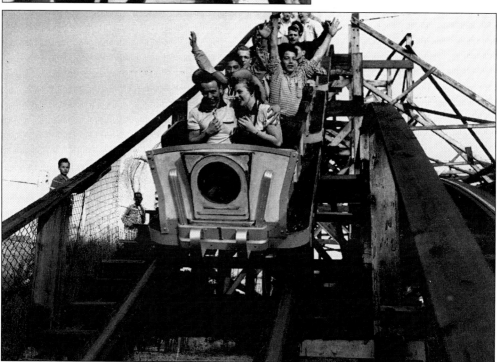

The Jack Rabbit received new trains in the early 1950s. Notice the revolving propeller in the porthole in the front of the train that lasted for only a few seasons. These trains, built by Ed Vettel Sr., who was superintendent of West View Park, are still in use on the Jack Rabbit, with the car fronts modified only slightly to a solid-wood panel. The ride's lower, far-turn tunnel that was removed in the 1940s was restored to its original location in 1991.

A new magnetic braking system was installed in 2002, and the classic hand-pulled brakes were replaced with electronically controlled pneumatic brakes. Even with these changes, the Jack Rabbit remains virtually the same ride as it was when it opened in 1920. Because little has changed to the coaster experience itself over the course of its existence, the Jack Rabbit was declared an ACE Coaster Classic by the American Coaster Enthusiasts (ACE) in the early 1990s.

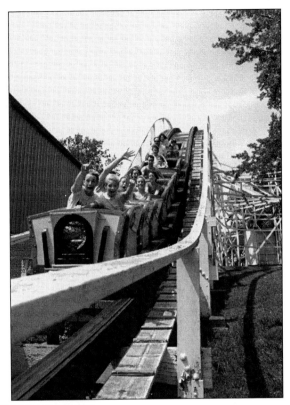

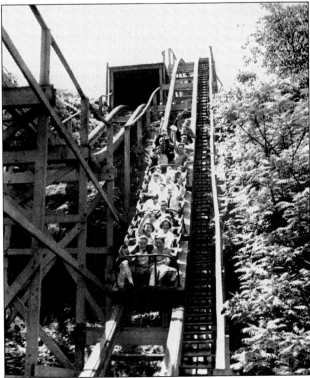

As with any success, a follow-up is usually in order. In 1924, Miller and Baker were hired once again to build another coaster for Kennywood. This time, they utilized a ravine on the other side of the park near the band shell and created an even larger coaster, the Pippin. Similar in design to the Jack Rabbit, the Pippin also had a double dip, only bigger and faster. Its largest drop, however, was saved for the ride's finale and was a huge 90-foot drop into the ravine.

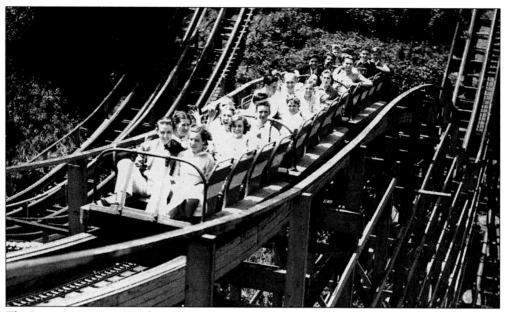

The Pippin's train engages the mid-course lift hill after experiencing two deep drops in the gully where it was erected. This ravine portion of the ride was retained and later incorporated into an entirely new coaster experience in 1968. The Pippin remained enormously popular throughout its 43 years of operation.

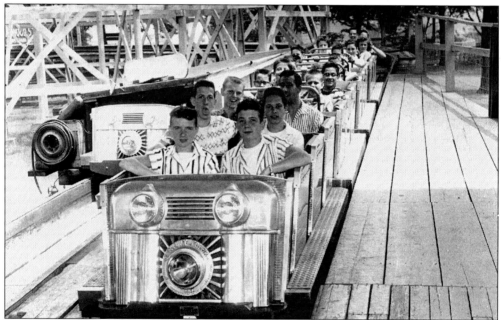

Three new trains were purchased in 1958 for the Pippin from the National Amusement Company of Dayton, Ohio, to replace the coaster's original open-front trains. The new trains were dubbed Century Flyers by the manufacturer and included three working headlights on their fronts. The center headlight actually revolved, creating an eerie oscillating effect during the course of the ride. These newer trains were retained for the Pippin's transformation after the 1967 season.

John A. Miller was hired, once again, to create one last coaster for the park. The original Racer coaster was torn down after the 1926 season due to age. It was decided that Miller would build a brand new racing coaster to replace it at the far end of the lagoon near the Jack Rabbit. The new ride was also called the Racer when it opened in 1927.

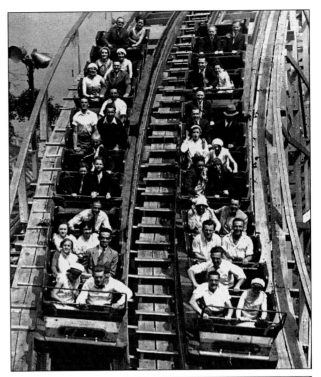

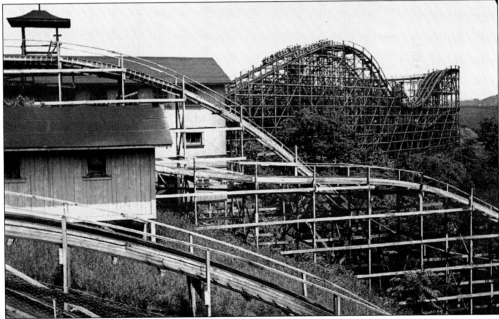

Unlike his previous designs for the park, John Miller did not utilize the natural topography as gracefully for the Racer as he had with the Pippin and Jack Rabbit (seen in foreground). The highest peak of the ride was built over the lowest part of the terrain, thus utilizing more wood for this ride than park management had anticipated. In fact, up to that time, the Racer was the most expensive coaster built in the park. Even with the higher price tag, the Racer became an instant success. (Charles Siple Collection.)

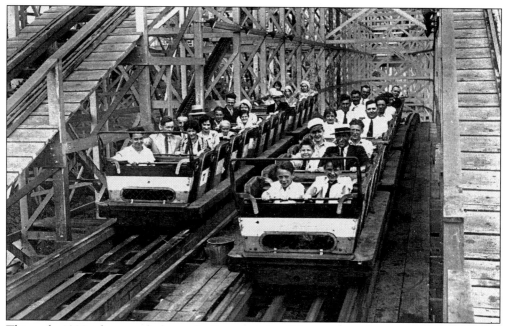

This early-1930s photograph shows the Racer's trains gliding to a gentle stop on the ride's brake run. A roof was erected later over the brakes to help protect them and keep them dry to better facilitate stopping. Notice how formal the riders appear with many of the men and boys wearing neckties, suits, and hats. Although the Depression during the 1930s affected the park severely, school picnics helped rides like the Racer to survive. (David Hahner Collection.)

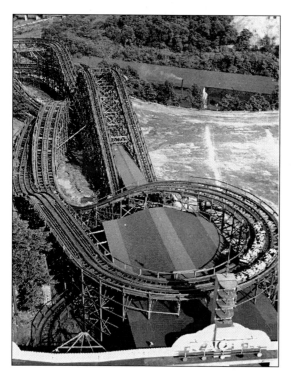

The new Racer featured an intriguing, single-track layout that let the racing trains alternate sides of the track. A train that started on the right side of the platform returned on the left side and vice versa. This aerial shot from 1946 demonstrates the beauty of Miller's design. The track splits just after leaving the station but stays side by side throughout the remaining course of the ride. It is this split that allows the two sides to actually be one long single continuous track.

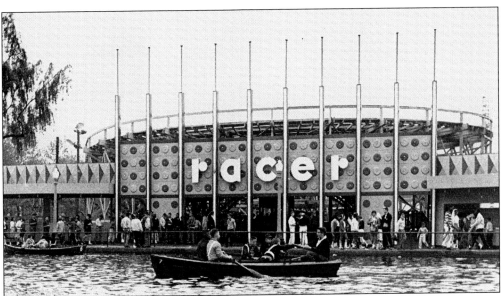

In 1960, the Racer, once again, received a new, more modern facade. The front panels of the facade were a deep blue, and red and yellow light-filled circles were added to the front. The kinetic effects of the flashing lights made the Racer an enticing and vivid piece of wonderment on the midway at night. During the 1970s, two of the trains were painted in similar hues to the facade, while the other two trains took on a more psychedelic look symbolic of that era.

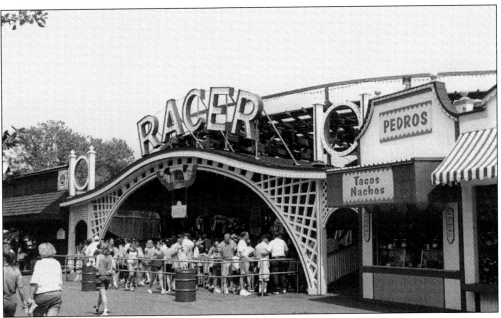

New signage was built to help re-create the original look of the ride's front, restoring it as it appeared when it had opened in 1927. Today, the Racer continues to thrill thousands of riders every summer. Although its classic original trains were replaced with three new Philadelphia Toboggan Company models in 1982, the Racer is still considered the world's oldest operating racing roller coaster, and it is only one of three single-track racing coasters in operation in the world.

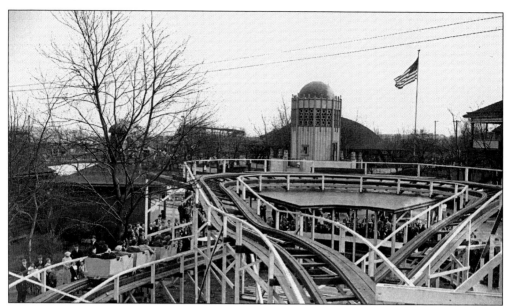

In 1935, park management decided to add a smaller coaster for kids, which resulted in the construction of the Teddy Bear coaster. Located between the park's band shell and Tower refreshment stand, it was designed by Herbert Schmeck of the Philadelphia Toboggan Company and featured two bear cubs on the front of the coaster's train. The Teddy Bear was only 20 feet high but a welcome addition for the smaller riders who were too short to ride the park's bigger coasters.

After the 1947 season, it was decided to replace the rather small Teddy Bear coaster with a slightly larger ride. Unlike previous coasters, the Little Dipper was designed and built by the park's head engineer, Andy Vettel. He utilized the Teddy Bear's Philadelphia Toboggan Company train and created a zippy little coaster that parents and children could enjoy together. He even incorporated a small John Miller–inspired double dip as one of the new ride's features, seen in this 1948 photograph.

Because of the post–World War II baby boom, it was decided in 1955 to enlarge the Little Dipper to handle two trains. Andy Vettel extended the ride's length and height, and two new trains were purchased from the Philadelphia Toboggan Company. The coaster's name was shortened to Dipper and featured a 40-foot first drop. Unfortunately, the ride's exciting double dip was removed during this renovation. The Dipper was removed in June 1984 for the construction of the park's Raging Rapids river raft ride.

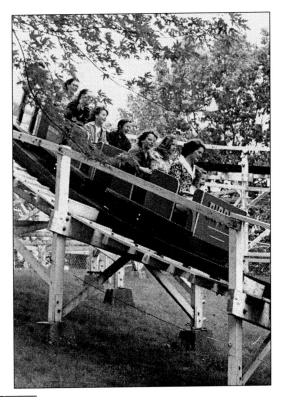

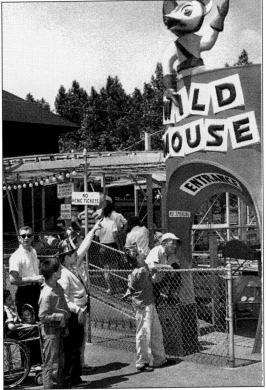

Kennywood added a B. A. Schiff–designed Wild Mouse steel coaster as a concession for the 1958 season. A series of single cars traversed a maze-like, zigzag formation, giving riders the illusion that their car would plummet to the ground as it traversed the tight U-turns of the track layout. The ride was located next to the old dance hall building, which then housed the Enchanted Forest children's walk-through attraction.

The small, two-passenger Wild Mouse cars followed a compact, narrow course throughout the ride. The use of a minimal support structure gave the ride a rather flimsy, unsafe look and feel, which helped create the illusion of danger. The tight U-turns of the ride provided heightened lateral-motion sensations within the smaller-scale ride vehicles. The park purchased the ride from the concessionaire and continued to operate it through the 1960 season.

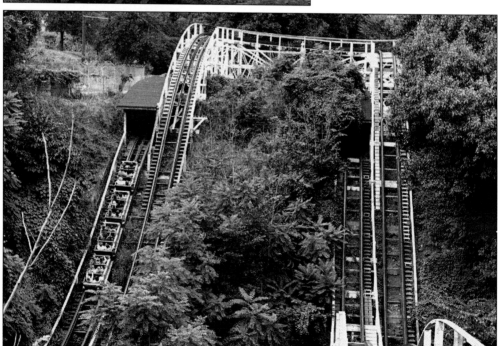

In 1967, Kennywood management did the unthinkable. They decided to close one of their most popular coasters, the Pippin, after the season was over and redesign it completely. After the redesign, all that was left of the ride was the ravine section, as seen in this 1968 photograph taken just after the transformation. The ride became the park's most famous and popular wooden coaster, Thunderbolt.

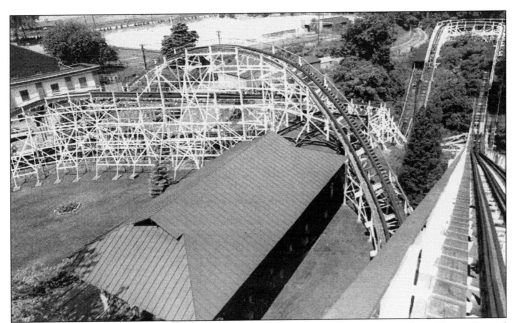

The lift hill of the Pippin was extended and its height increased. The park's Whip ride and building were moved next to the pony track on the other side of the park near the Racer. A unique series of twisting drops and turns were added along the midway to produce a much longer, intense, and, more importantly, visual coaster experience to the riders and passersby alike. A contest was held to name the new ride, and Thunderbolt was the name that was chosen.

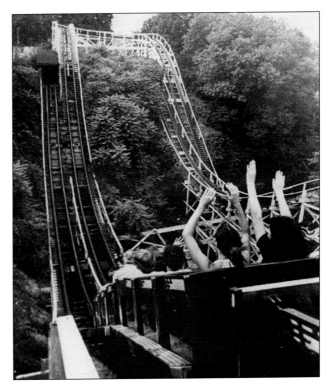

The station was moved within the ride's new structure, literally to the edge of the ravine. When the train is released from the station, it immediately plummets down a 50-foot drop! There is no time for riders to acclimate themselves to the ride by climbing a slow lift hill to the top first. The action begins from the moment the train is dispatched.

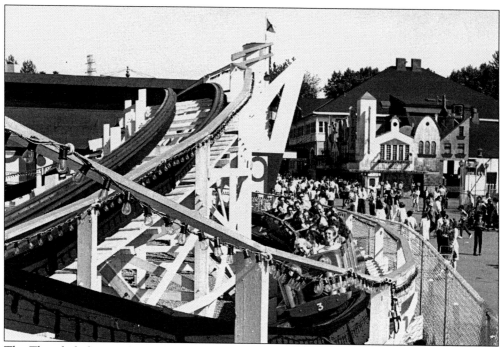

The Thunderbolt is perfectly named since its thunderous roar can be heard loudly throughout the midway when it races at ground level nearby. In this rare photograph, notice the higher track to the left. This was a small hill that was removed and leveled after the first season for operational reasons. Much of Thunderbolt's popularity comes from its combination of tight turns and large, steep, unexpected drops. It is this uniqueness that brought praise and recognition for the coaster.

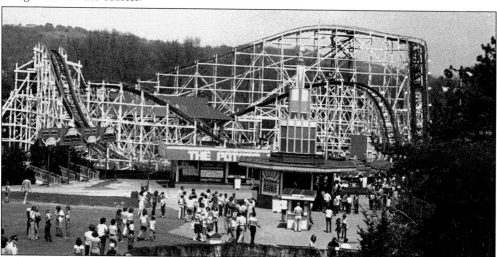

In 1974, noted coaster historian Robert Cartmell, in a *New York Times* article, proclaimed the Thunderbolt his "ultimate roller coaster." From this view, you can see the twisting "spaghetti bowl" of track that Andy Vettel created in contrast to the simplistic out-and-back drops of the 1924 ravine section that was built by John Miller. It is this magnificent merger between old and new that makes the Thunderbolt so special. The American Coaster Enthusiasts also designated the Thunderbolt as an ACE Coaster Classic in the early 1990s.

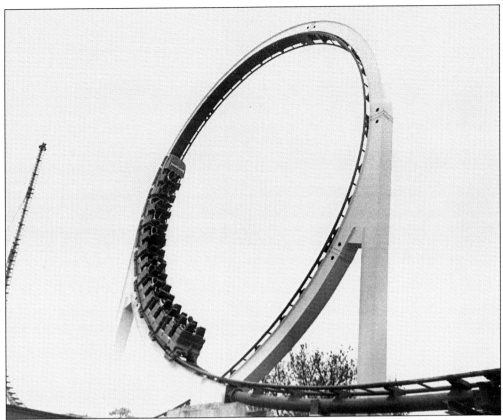

Kennywood entered the modern era of steel roller coasters with the addition of the Laser Loop in 1980. It was not only the park's first major steel coaster but also the first coaster with a looping inversion to be added to the park. Built and designed by the famed German coaster designer Anton Schwartzkopf, it literally launched riders from 0 to 55 miles per hour in a mere four seconds!

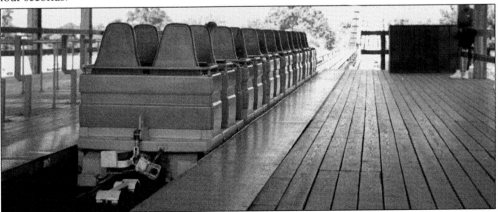

Riders prepare to be launched from 0 to 55 miles per hour in the Laser Loop's station. Two operators were needed to launch the train. Once riders are secured in their seats, the operator in the front of the platform keeps the launch button depressed while the person in the operations booth depresses his (or her) launch button simultaneously to activate the catapult mechanism. (Photograph by David Hahner.)

Riders do not know which way is up while navigating the 72-foot-high loop of the Laser Loop. The riders are shot forward through the vertical loop with the use of a flywheel catapult system, similar to those systems found on aircraft carriers. Earlier models of this same style of coaster used an extremely heavy weight in an enclosed cylindrical tower at the far end of the ride to pull the train to its maximum speed when it was dropped.

After traversing the loop, the Laser Loop's train ascended a 139-foot hill where it momentarily stopped, then rolled backwards down the incline and went through the loop again, all in reverse! There was little time to catch one's breath during the fast-paced experience.

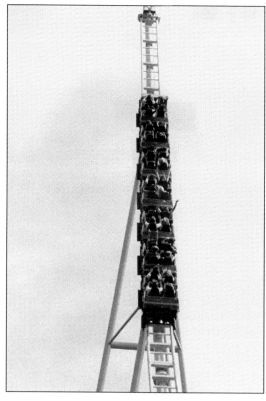

The coaster train of the Laser Loop then rolled full-speed backwards through the loading platform to another 110-foot-high, steep incline where the train paused once again, then rolled forward to the braking area just before the station. The entire exhilarating experience from launch to brake lasted a mere 30 seconds! The Laser Loop operated for 11 seasons and was removed after the 1990 season for the construction of a much bigger and more ambitious coaster project. (Photograph by David Hahner.)

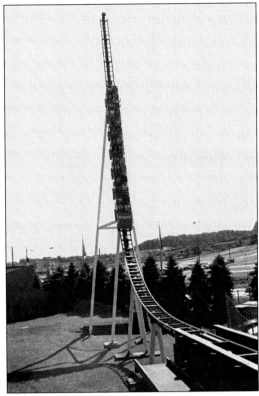

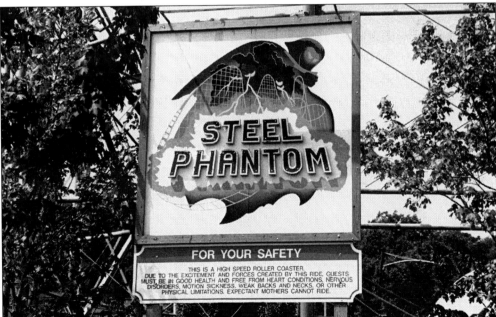

In 1991, the landscape of Kennywood forever changed with the addition of the enormous Steel Phantom steel roller coaster. Conceived by park president Harry W. Henninger Jr. and created by Arrow Dynamics of Clearfield, Utah, the Steel Phantom was undoubtedly the park's most ambitious coaster project ever. (Photograph by David Hahner.)

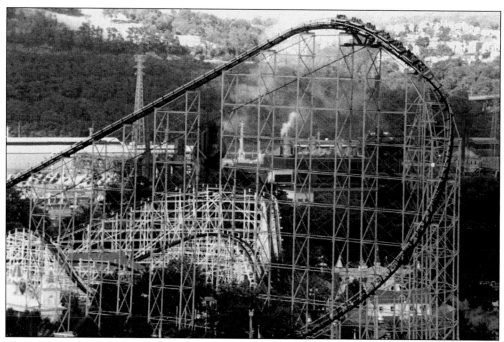

The 165-foot lift hill for the Steel Phantom (now Phantom's Revenge) follows the course of the former Laser Loop coaster. The swooping turn drop seems to dive straight down toward Kennywood Boulevard before leveling out at the bottom. The sheer size and height of this drop was purposely placed along the highway to get people's attention as they drive by or arrive at the park.

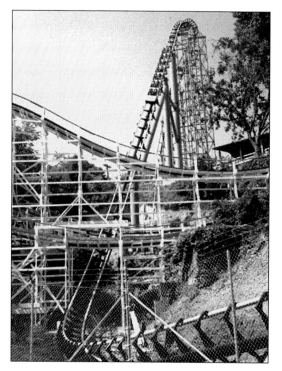

What made the Steel Phantom unique was that the largest hill was not the first drop but the second drop. Here, the train races down a then record-breaking height of 225 feet straight through the structure of the Thunderbolt, hitting a top speed of 80 miles per hour, also a world record in 1991. Diving through the Thunderbolt's structure adds an increased thrill to the ride with a feeling of near decapitation. (Photograph by David Hahner.)

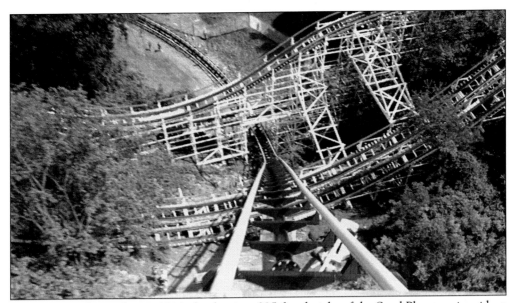

In this point of view shot in 1991, the dizzying, 225-foot height of the Steel Phantom is evident as the track slices through the Thunderbolt's support structure. This was a key element that park president Harry W. Henninger conceived for the ride, and it became the ride's signature feature after opening. Due to the park's limited space, Arrow Dynamics engineer Ron Toomer had to squeeze the large ride into a relatively small area. (Photograph by David Hahner.)

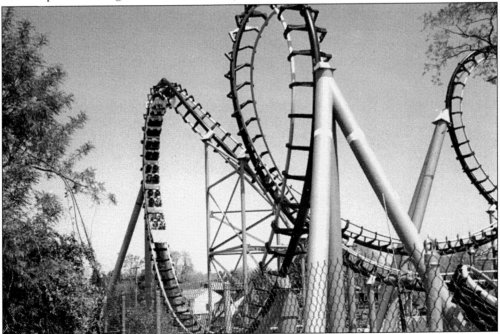

The Steel Phantom's trains came out of the deep ravine and entered a series of looping inversions—a vertical loop, a double-looping boomerang inversion, and, finally, a single corkscrew. Steel Phantom instantly became a top-ten steel coaster for many enthusiasts. Its combination of record-breaking speed and aerial acrobatics gave a ride like no other coaster had before. (Photograph by David Hahner.)

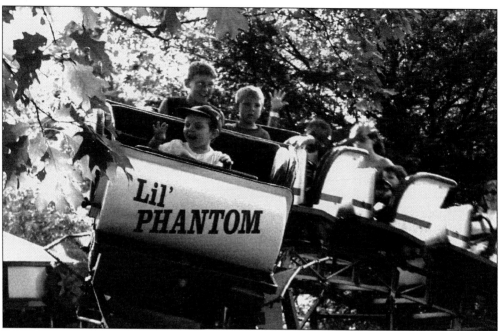

In 1996, the park added its first coaster aimed for kids since the demolition of the Dipper in 1984. Only about 10 feet high, Li'l Phantom, in Kiddieland, offers little thrill seekers coaster excitement on a smaller scale. It sits on the former location of the Kiddie Old Mill ride that closed during the 1970s. (Photograph by David Hahner.)

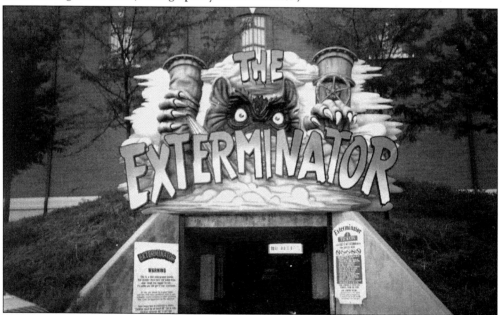

Kennywood purchased one of the most unusual coasters ever built, a Reverchon-manufactured Crazy Mouse coaster. A large building was erected to house the French company's ride on property directly adjacent to the park's original boundary line, at the far end of the Lost Kennywood section of the park. This was the first time the park had expanded beyond the perimeter of its original property line. (Photograph by David Hahner.)

Within the building, a modern variation of the 1950s-era Wild Mouse coaster was installed. This time, the ride came with a new twist, in more ways than one. Part dark ride, part coaster, the new heavily themed attraction, named the Exterminator, became an instant sensation when it came to life in 1999. Themed as a rat-infested sewer system, riders board the giant rat-shaped cars and are pursued by animated "exterminators" during the course of the ride. (Photograph by Rick Davis.)

Midway through the ride, a release mechanism allows the cars to start to spin wildly in the dark, adding to the excitement. Originally, a modern, non-spinning Wild Mouse was purchased in the early 1990s to create this ride but was later installed in 1992 at nearby Idlewild Park in Ligonier, which is owned by Kennywood. Company president Harry W. Henninger test rode a model of the spinning Crazy Mouse blindfolded at a park in New Jersey to see how it would ride in the dark before purchasing.

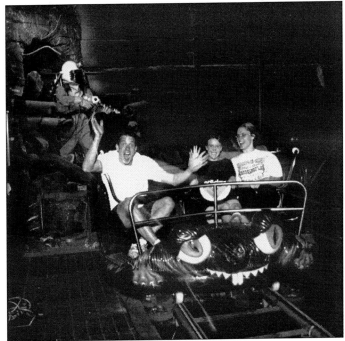

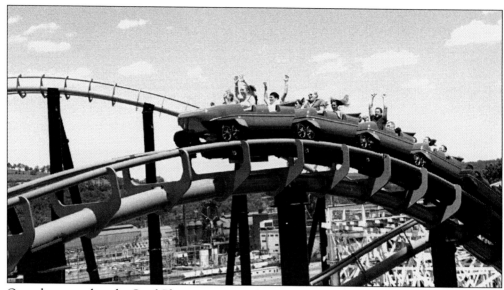

Over the years that the Steel Phantom operated at Kennywood, park officials noticed that the lines for the large coaster were getting shorter every year. It was discovered that the looping inversions of the ride were just too intense for the average coaster rider. Similar to its decision to convert the Pippin into the Thunderbolt more than 30 years earlier, the park hired Morgan Manufacturing to redesign the ride. It became more like other popular "hyper-coasters" of the era: fast and thrilling without the intensity of the loops. (Photograph by Rick Davis.)

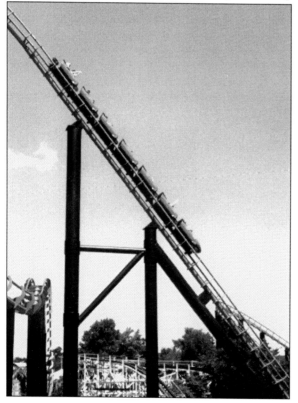

The new coaster was dubbed Phantom's Revenge. It kept the parts of the ride that made the original Steel Phantom so famous—namely, the first two drops. Actually, the once record-breaking 225-foot drop was extended to 230 feet. Additional track was added creating a wild out-of-your-seat experience like no other. The new ride opened in May 2001 and instantly became a park favorite. Phantom's Revenge is just the latest addition to an already impressive roller coaster roster at Kennywood spanning the last century. (Photograph by Jim Futrell.)

Six

THE DARK SIDE
OF KENNYWOOD

Not all of the thrills at Kennywood come from roller coasters, or thrill rides. Some are more psychological in nature, arising from man's deep inner fears of the unknown and the dark. Thus, like watching a good (or most often bad) horror movie, Kennywood has added a number of attractions over the years that help prey on the deep-seated fears of most people. Of course, like the roller coasters and other rides, the masses love to get scared by them, to take a brief trip into the unknown and stir those primeval instincts of fight or flight. Such names as Ghost Ship; 13 Spook Street; Le Cachot, French for "the Dungeon"; Haunted Hideaway; and the Exterminator immediately evoke images of something terrifying, or menacing. But other names such as Old Mill, Noah's Ark, Enchanted Forest, Bug House, Daffy Klub, and Laff in the Dark do not. Yet each offers its own set of thrills, scary or funny, that usually ends in laughter, from either the relief of conquering our fears or the simple fact that it was hilarious in nature, intentionally or not.

Dark rides, such as Laff in the Dark, Zoomerang, Tornado, Ghost Ship, Le Cachot, and Gold Rusher, usually try to scare riders in their slow or quick-moving vehicles with sudden sights, loud noises, and mostly the dark. More often than not, the scenes, or "stunts" as they are known, are hokey and laughable, at best. But not all of the dark rides are designed to be scary. The various incarnations of the Old Mill, the park's oldest ride, kept its basic theme as a "tunnel of love" (ironically, a name that it was never called) throughout its history. With its long dark tunnels, it was known more for passionate liaisons with young lovers than anything truly frightening. Even when known as Hardheaded Harold's Horrendously Humorous Haunted Hideaway, filled with spooks and skeletons, every scene was tongue in cheek and far from being actually terrifying. Today as Garfield's Nightmare, it is designed as a family friendly three-dimensional adventure where the frights are intentionally comical in nature.

Fun houses did not always scare either. The parks first fun house, or "pavilion of fun," opened in the early part of the 20th century as the Wonderland Building. It later became known by such names as Daffy Dilla, Hilarity Hall, Bug House, and Tut's Tomb. It was an open-air structure that featured stunts, such as moving stairs, spiral slides, spinning barrels, and other physical activities that often ended in uncontrollable laughter. Later fun houses, such as Noah's Ark, 13 Spook Street, and Daffy Klub, featured stunts and dark-ride-type scenes mixed within dimly lit, confusing mazes.

Now, if you are brave enough, let us take a look at a history of Kennywood's "dark side."

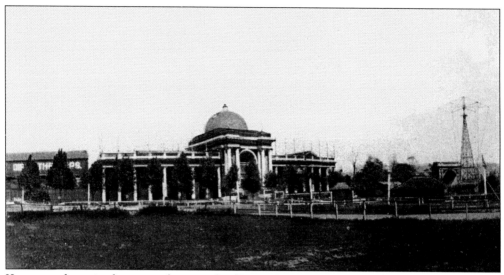

Kennywood received not one but two fun house–type attractions in 1902 with the addition of the Laughing Gallery and Wonderland Building (also known as the Steeplechase Building when the ride operated). Both of these attractions featured fun house–style mirrors that delighted guests by offering grotesquely distorted views of themselves. Laughing Gallery was located near the Old Mill, and the much larger Wonderland Building (pictured) was at the opposite end of the park. Wonderland also offered the Dew Drop slide and an earthquake floor. (Jim Futrell Collection.)

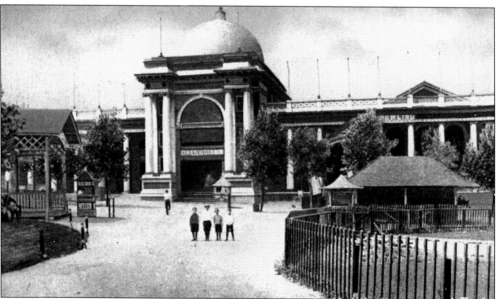

The Wonderland Building was renamed Daffy Dilla in 1912. A few new stunts were added, including a Human Roulette Wheel. Additional stunts were added over the years, including shaking stairs and floors, slides, and other similar contraptions. The building was renovated once again in 1915, receiving a new front and a new name, Hilarity Hall. Many more stunts were added, including such oddities as Earthquake Stairs, Lung Tester, Undulating Walk, and Perfume Machine. A few years later, it became known as the Bug House. (Dick Bowker Collection.)

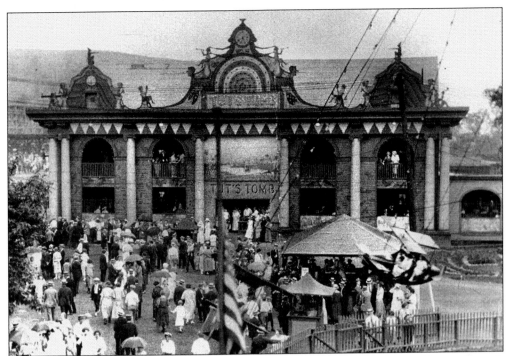

In 1924, the Bug House was renamed Tut's Tomb with the discovery of Tutankhamun's tomb in Egypt. It was renamed back to the Bug House in 1928. The attraction closed after the 1934 season, not for its unpopularity but because people would not leave the building after paying their admission, spending hours in the facility. The Skooter ride replaced it in 1935, which was installed in the building's first floor. Many of the stunts remained dormant upstairs until the building was demolished in 1979.

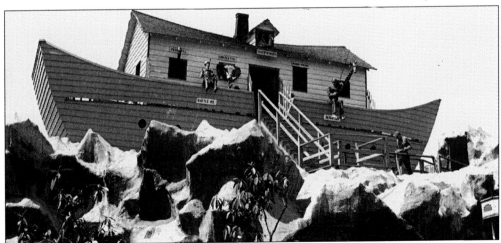

In 1936, Kennywood built what became one of its most famous landmark structures and attractions: Noah's Ark. The new fun house was designed and built by Herbert Schmeck of the Philadelphia Toboggan Company. It was based on designs of similar rides that were developed by the defunct Noah's Ark Company, once owned by famed carousel maker William Dentzel. Ironically, the ark opened the year of Pittsburgh's most devastating flood, which occurred on St. Patrick's Day, March 17, 1936. (Charles Siple Collection.)

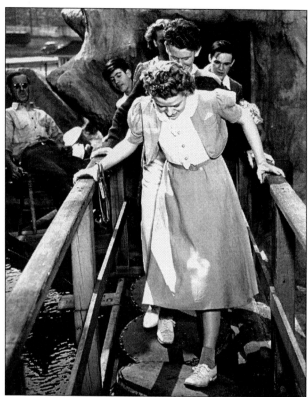

In this 1940 photograph, guests entering Noah's Ark try to maneuver across the "waddling lily pads" stunt. The wobbling circular foot pads were difficult to walk across without holding on to the handrails. The attendant sitting in the chair controlled hidden air jets that were located at various spots along the walkway. The sudden rush of air would lift women's skirts and dresses, giving an added excitement! Notice the moat of water underneath, which once surrounded the base of the rocking ark.

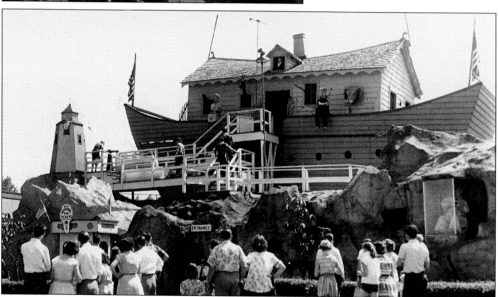

Noah's Ark became an instant success at the park. In 1941, an additional walkway was added to the front of the rocking boat with more obstacle stunts to traverse. Within the maze-like passageways of the boat and surrounding structural mountain, guests navigated additional stunts, such as moving floorboards, rubbery floors, and shaking floorboards. The attendant who operated the infamous air jets was now housed within the little lighthouse on the left, hidden from view.

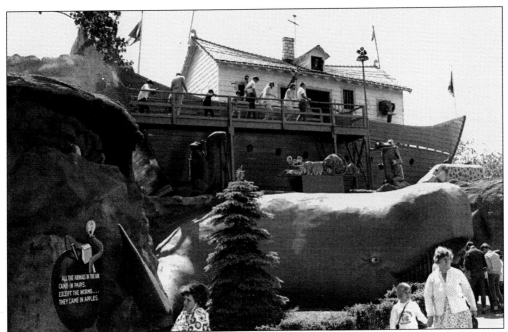

Noah's Ark remained relatively unchanged until 1969, when a major reconstruction of the ship's mountain took place. A new Mount Ararat was constructed to the left side of the boat, and the entire lower portion of the fun house was redone. A tilted room, a jungle setting with a suspension bridge over a hippopotamus pool, and a revolving barrel were added inside the structure. New figures of animals and Noah and his family were also added inside the rocking ship.

Guests now entered the Noah's Ark attraction through a large blue whale's mouth that had a spongy tongue. A miniature railroad track encircled the outside of the ark with two trains of cartoonish animals that rode upon it. Most of the ark's original obstacle stunts, with the exception of the shaking floors, had been removed due to changing insurance regulations. The air jets were also removed as a sign of the changing times and women's fashions.

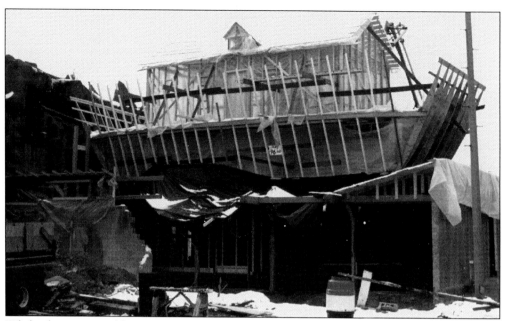

While planning to add a new fun house experience to Lost Kennywood, it was discovered that Noah's Ark was in desperate need of renovation. Park management decided to scrap the new fun house in favor of completely restoring the ark. This time, they planned to not only renovate the surrounding mountain but also refurbish the 60-year-old rocking boat. Unfortunately, the age and condition of the ark was much worse than anyone had anticipated. So a brand new, exact replica of the original ark was built to replace it. (Photograph by Jim Futrell.)

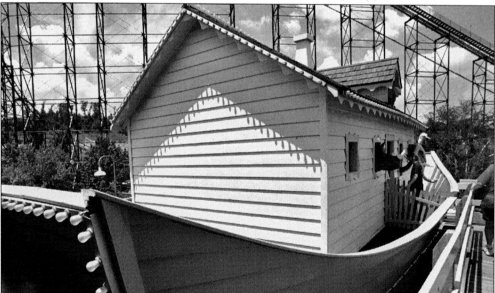

The exterior of the new ark was so exact in its replication that even the most die-hard Kennywood fans had no idea that most of the original boat was demolished. Though no blueprints of the original ark existed, Kennywood's skilled craftsmen faithfully reproduced it from photographs and measurements. Ironically, another terrible flood occurred in the Pittsburgh region during the construction of the new ark in January 1996. (Photograph by Rick Davis.)

New, high-tech stunts and effects were added throughout the newly expanded mountain sections, including the Storm at Sea room (pictured) and the Kennywood Bathosphere, where a wall of water deluges unsuspecting guests in a surprisingly wet finale. Gone was the familiar blue-whale entrance, which was replaced by the Elevator of Doom, offering a simulated free fall down a maintenance elevator shaft. The only surviving stunts from the old ark, aside from the rocking boat itself, are the shaking floorboards. (Photograph by Rick Davis.)

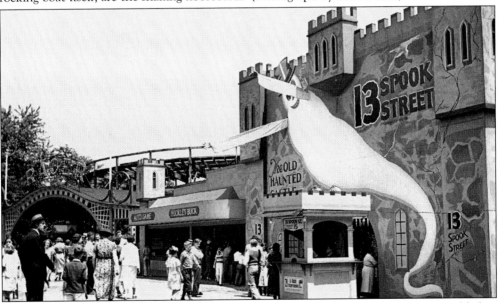

With the instant success of Noah's Ark in 1936, another fun house attraction was added in 1937 named 13 Spook Street. Built on the far edge of the Kennywood Lagoon, between the Racer and Jack Rabbit coasters, it replaced an earlier walk-through attraction, Fun on the Farm, which only lasted two seasons. Themed as a haunted castle, 13 Spook Street was filled with scenes of silly spooks and crazy stunts, including a moving sidewalk exit to the ride. (Charles Siple Collection.)

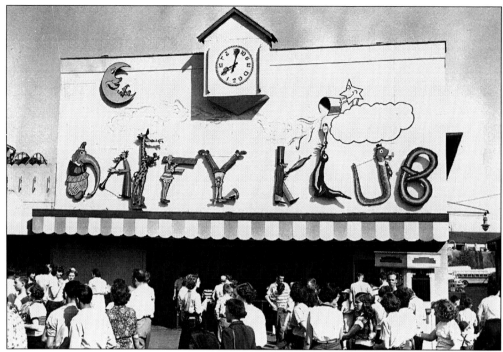

The Daffy Klub replaced 13 Spook Street in 1941. A tilted room and other stunts were purchased from the Philadelphia Toboggan Company, which also redid the attraction's facade. The Daffy Klub's marquee comically claimed that the attraction was "Scair-Conditioned." In the early 1950s, the Daffy Klub received a makeover of its facade (pictured), along with a few new stunts, including the Wonderland Building's original antique distortion mirrors. The attraction lasted until 1955, when it was permanently closed and replaced with the Pastime game.

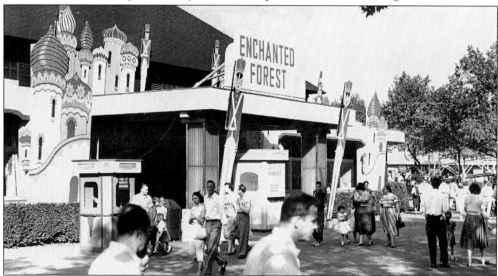

The historic dance pavilion closed to dancing in 1953. As one of the original park buildings built in 1899, it signaled the end of a major era in the park's history. In 1954, the building was converted into a children's walk-through attraction called Enchanted Forest. Themed to children's fairy tales, it gave families a not-so-scary fun house–type of experience.

One of the highlights from the Enchanted Forest that was added in 1956 was a closed-circuit television system. This allowed visitors to see themselves on TV, which was still a novelty at the time. In 1960, the exterior of the Enchanted Forest was re-themed into the Enchanted Castle. A new, spooky dungeon was added as part of the renovation. The attraction closed after the 1962 season to make way for the Tornado dark ride.

The Old Mill continues to be the oldest operating ride in Kennywood, as well as the park's oldest dark ride. A new elaborate mill facade was part of the extensive 1922 enlargement. The paddle wheel for the ride is not just there for decorative purposes; it *actually* supplies the water current for the boats. Although the ride's name and interior scenes of the attraction have changed over the years, the ride system has remained virtually unchanged since its remodeling in 1922.

73

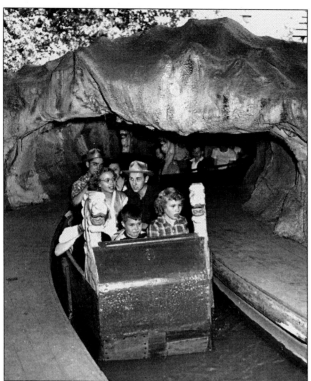

In 1957, the Old Mill received a trip-around-the-world theme. Interior scenes featured a hula dancer in Hawaii, Santa Claus at the North Pole, an Aboriginal boy and kangaroo in Australia, and a ferocious tiger in Asia. Exterior scenes included Tarzan swinging on a cable, an African bull elephant, and a large skull waterfall. An animated monkey band sat in a box suspended above the loading area, entertaining guests while they waited to board. Note the hand-carved dragon heads on the boats, which were removed in 1974.

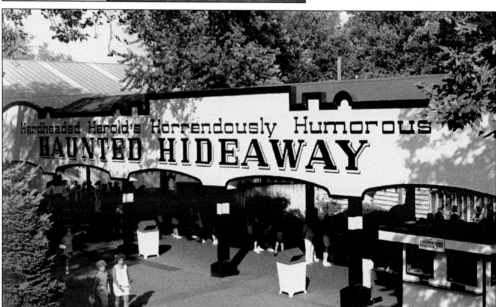

The Old Mill in 1974 received a haunted, old-west ghost town theme and the most unusual name of Hardheaded Harold's Horrendously Humorous Haunted Hideaway, or just Haunted Hideaway for short. The new theme featured skeletons and ghosts throughout, including a collapsing mine shaft with skeleton miners, two skeletons trying to escape from jail with a sleeping skeleton sheriff, a rowdy haunted saloon, and an eerie blacksmith shop with invisible blacksmiths plying their trade.

In 1992, the ride was once again renamed the Old Mill. The venerable ride celebrated its centennial in 2001 and was honored by the Darkride and Funhouse Enthusiasts organization as the oldest operating dark ride in North America. In 2004, the Old Mill was once again re-themed and renamed Garfield's Nightmare. Based on the famous comic-strip character created by Jim Davis, the lovable feline, and his friend Odie, must deal with Garfield's food-born nightmares as they come to three-dimensional life within the ride. (Photograph by David Hahner.)

Kennywood added its first electrified-track dark ride in 1930 with the addition of Laugh in the Dark. The building that once housed the Dodgem ride to the right of the Old Mill was completely enclosed. Harry Traver of Traver Engineering in Beaver Falls was hired to install the new ride, developing the stunts as well as the vehicles and track.

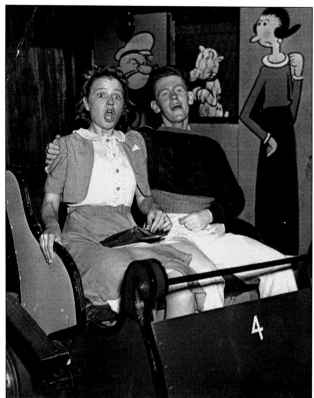

Laff in the Dark (as the ride later became known) was a hysterical journey through the dark. The two-passenger vehicles banged sets of doors open to travel through various comical scenes, sometimes featuring famous comic-strip characters. Much of the animation was just two-dimensional wooden flats, but sudden lighting and loud noises helped to scare the riders.

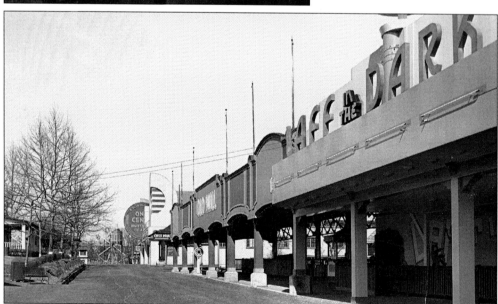

Two of Kennywood's great dark rides, the Old Mill and Laff in the Dark, stand side by side along the entrance midway to the park in this 1940 photograph. Laff in the Dark's facade was re-done to an Art Deco front in 1939 to help give it a fresh new look. In 1941, a Laughing Sal animated figure was added to the front of the ride. Today, Sal has been completely restored and is still laughing in the front window of the Old Kennywood Railroad station.

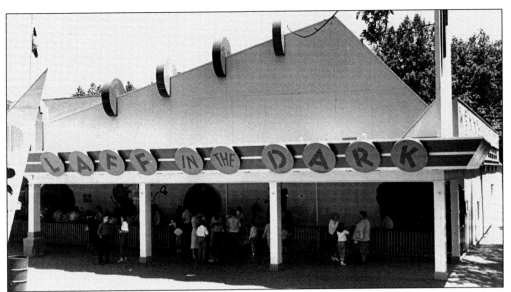

Laff in the Dark's facade was upgraded for the last time in 1960, with a new, modern space-age look. The ride was closed after the 1965 season to make way for the new Turnpike gasoline-powered automobile ride. Laughing Sal was put into storage, as were the ten two-passenger dark-ride vehicles, which found a new lease on life two years later.

A new mystery dark ride was added in 1954 to replace the Snapper (Cuddle-Up) ride. A naming contest for the new ride was held on a local television show, and the name Zoomerang was chosen. The new facade sported a 1950s-style, futuristic, world's fair design. Spinning dark-ride vehicles were purchased from the Pretzel Amusement Ride Company for use in this jungle-themed attraction. But due to complaints from riders and maintenance staff alike, the vehicles only spun for that first season.

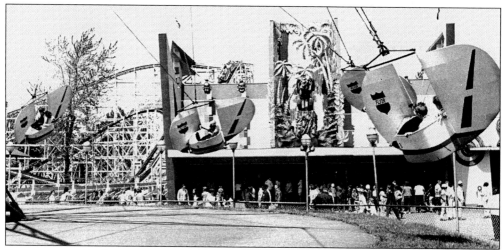

Zoomerang received new stunts and a remodeled facade in 1961 and was renamed Safari. Legendary 1960s dark-ride designer Bill Tracey designed the new interior stunts and scenes, as well as the giant Zulu warrior that stood in the front of the facade. The warrior was removed in the late 1960s and was replaced with a large lion. The Flyer flying-skooter ride is in the foreground.

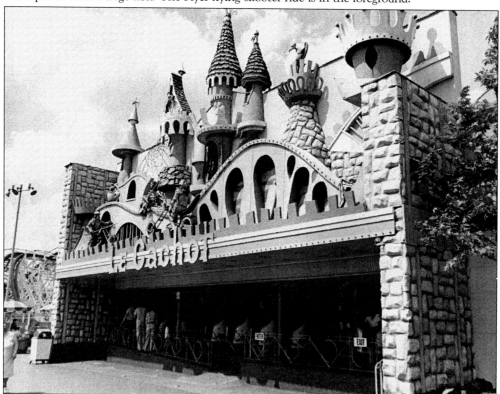

In 1972, the Safari dark ride was re-themed by Bill Tracey once again. His new creation was a wacky and spooky 1970s vision of a haunted castle's dungeon known as Le Cachot. Utilizing the same cars with a slightly elongated layout of the Pretzel-designed ride that preceded it, the new ride featured pop visions of a gothic castle. With this strange combination, Le Cachot managed to be frightening and hilarious at the same time.

Tacky, yet delightful, was the craziness of Le Cachot. Influences from the early 1970s pop culture included a hippie snake wrapped around a peace sign, jousting knight skeletons on motorcycle choppers on the ride's facade, and a psychedelic flashing strobe-lit room that offered a dizzying, and popular, finale to the ride. The ride was removed, and the building razed after the 1998 season.

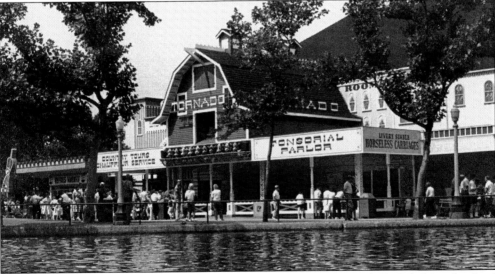

In 1963, Kennywood purchased the Tornado dark ride from the financially failed Freedomland theme park in New York City. Freedomland was to be the East Coast's answer to Disneyland in California but could never draw the crowds needed and lasted only four years. The Tornado was one of three Arrow-designed dark rides that existed at the park. The other two were the San Francisco Earthquake and the Buccaneer (Pirate Ride), which were both purchased by Cedar Point.

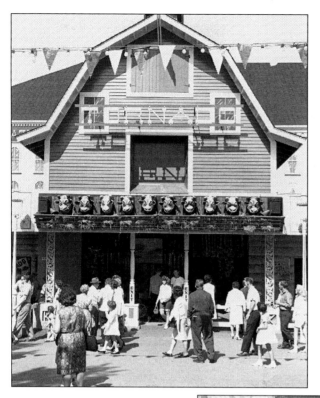

The Tornado dark ride was installed in the former Dance Hall building, replacing the Enchanted Castle walk-through attraction. The theme to the attraction was a small, rural Midwestern town that was being ravaged by a tornado. Various scenes had building walls crumbling, stacks of barrels swaying, and a barn filled with livestock, such as cows and chickens, flying overhead. Large fans were installed to help guests feel the fury of one of nature's most unpredictable forces.

The ride vehicles, designed by Arrow, resembled antique automobiles from the early part of the century. In a strange mix-up, the cars for Kennywood's Tornado ride were actually used on the Earthquake ride at Freedomland, and horseless-carriage vehicles were used for the Tornado ride when it operated in New York. Kennywood and Cedar Point actually received each other's ride vehicles!

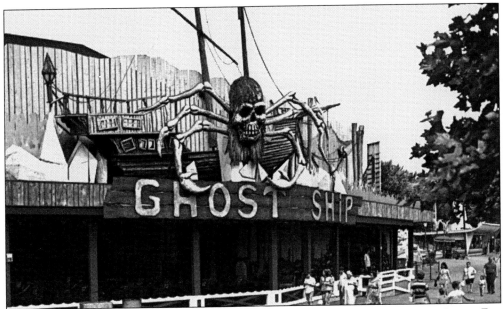

The Ghost Ship dark ride replaced the Tornado in 1967, which was sold to Great Escape Fun Park in Lake George, New York. Ghost Ship was the largest dark ride to be built at Kennywood and was also designed by Bill Tracy. The cars that traversed the interior were the original cars that ran on the former Laff in the Dark dark ride that was removed in 1965. They were re-themed to look like small derelict sailing ships.

As was typical with Tracy's work, Ghost Ship was filled with wacky and spooky stunts from skeleton pirates to ghastly sea creatures. This pre-production artwork shows off one of the wacky scenes, featuring a spooky skeleton in an outhouse. The skeleton slammed the door shut as the car went by. Other similar gruesome, yet silly, gags were found throughout the ride.

SCENE Ⓔ
AIR

This poor pirate was lashed to the wheel of his ship. Actually, this scene was at the end of a long, black-lit, revolving barrel. The wheel spun at the same rate as the barrel, which caused a convincingly dizzy effect. Two of these fluorescent-painted barrel effects were used during the course of the ride, as well as a strobe-lit mirror room. The end of the ride featured a waterfall blocking the final set of doors. It magically shut off just before the car banged open the exit doors.

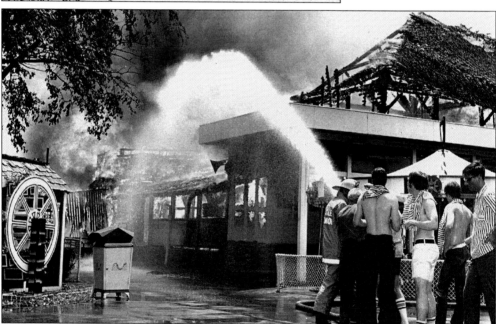

Tragically, the Ghost Ship and the entire dance hall pavilion, along with the Road Runner cuddle-up ride, the kiddie Whip, and a German kiddie vehicle carousel, were all destroyed in a large fire that occurred on June 19, 1975. Two other rides, the Satellite and Calypso, were also heavily damaged by the blaze. Fortunately, no one was injured during the fire, and all riders were led to safety thanks to quick-thinking park employees.

The addition of Kennywood's last traditional-style dark ride came in 1981 with the opening of Gold Rusher. The park's Sportland games building adjacent to Le Cachot received a new second story where the ride would be located. Maurice Ayers, a former Hollywood movie-set designer whose film credits include *The Ten Commandments*, designed the ride's scenes and effects. The entrance to the ride was located directly behind Le Cachot building.

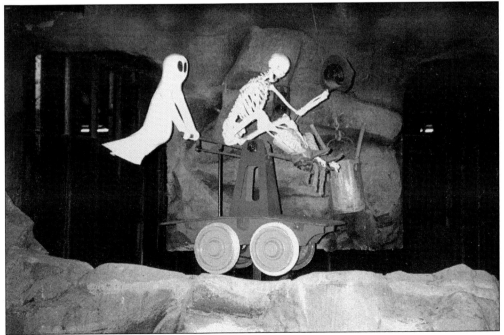

Maurice Ayers' style was surprisingly similar to Bill Tracey's, developing scary, yet humorous, scenes that can sometime startle. Loud sound effects and sudden lighting help make this ride a perennial favorite for young and old alike. His attention to detail within each scene adds to the enjoyment. (Photograph by David Hahner.)

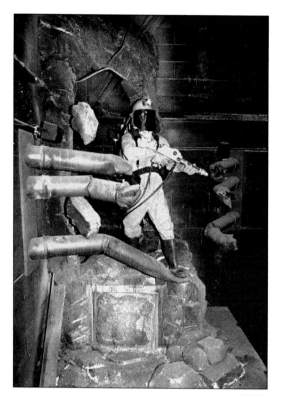

Although the Exterminator, which opened in 1999, is mainly an indoor spinning roller coaster, it does offer some great dark-ride elements that were designed partly by Sally Corporation, a leader in modern dark-ride animatronic figures. Watch out for the exterminators whose mission is to destroy all the giant rats (the ride vehicles) in the Kennywood sewage system! Other effects and scenes were designed by Kennywood's own skilled craftsmen. (Photograph by Rick Davis.)

Kennywood's tradition of closing for the season on Labor Day ended in 2002, when the park introduced Phantom Fright Nights, a Halloween-themed event. On Friday and Saturday evenings in October, the park is transformed into a frightening display of ghouls and monsters. The event essentially transforms the park into one giant haunted fun house. Walk-through mazes and outdoor fright zones combine with the traditional thrills of coasters and other selected rides to help guests get into the "spirit" of the season in this popular end of season event. (Photograph by Rick Davis.)

Seven

PLANES, TRAINS, AND AUTOMOBILES (AND PONIES, TOO!)

From the beginning, transportation has played a key role in the development of Kennywood. As is known, Kennywood Park was created to increase ridership for the Monongahela Street Railways Company. Most visitors in the earlier decades of the park arrived by trolley to enjoy a carefree summer's outing in the wooded atmosphere of Kennywood. In fact, part of the fun of going to Kennywood was taking the trolley, or street car, to the park. Others arrived by train to a station at the base of the bluff below the 1924 Pippin roller coaster. As the years progressed, the automobile became equally important to the success of the park, eventually replacing the trains and trolleys as the main form of conveyance to the park.

But transportation within the park also became an important factor in Kennywood's success. Over the years, youngsters pretended to be taming the Wild West while riding on a live pony or took a scenic miniature train ride with their families through the park's beautifully landscaped grounds. They could believe that they were soaring through the clouds on an airplane on the circle swing or even to outer space in a rocket in later years. As the automobile became more and more popular, so did the demand to drive them for young and old alike. Visitors could drive their own vehicle on the Auto Ride, and later the Turnpike. Or they could experience a fun version of a traffic jam by literally bumping other vehicles in the Dodgem, Skooter, or the bumper cars of the Gran Prix. Yes, Kennywood is *filled* with various forms of transportation, for that is what an amusement ride is. But instead of taking you from place to place, it lets your imagination soar and delights the senses. It transports you away from the troubles of the real world, if only for a short while. That is the true magic of Kennywood.

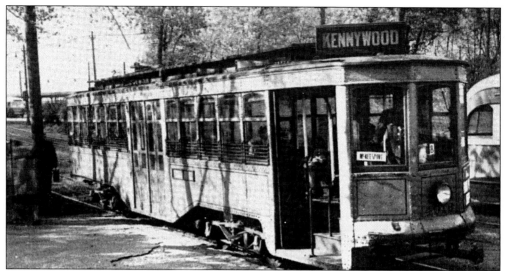

Getting to Kennywood was part of the fun. Depending on where they would board, guests could view the downtown sections of Pittsburgh, then travel through various ethnic residential neighborhoods surrounding the city. Farther on, they would pass the bustling, smoky steel mills of Homestead. Eventually, traveling on the high bluff that overlooks the Monongahela River, they would arrive at Kennywood Park. The trolleys ran to Kennywood until the late 1950s. (Dick Bowker Collection.)

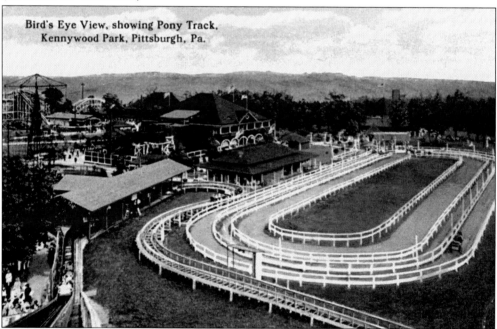

Children have always seemed to have a fascination with horses and ponies. Although youngsters could ride the hand-carved wooden horses of a carousel since 1899, the thrill of riding a live pony was always more exciting. The park introduced its first pony track in 1903 near the Casino restaurant. This photograph was taken from the top of the lift hill for Speed-O-Plane coaster. Its station can be seen to the left of the pony track and was located where Noah's Ark sits today. (David Hahner Collection.)

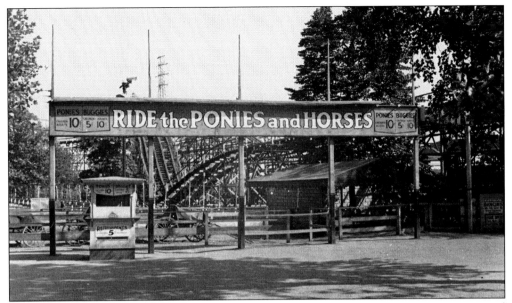

The pony track was moved in 1925 to the site of today's Kiddieland between the old Racer and the dance hall. It then was relocated in 1927 to where the Auto Race now stands, replacing the old Racer's station and lift hills. In 1930, the ponies moved once again to a shady area of the park next to the new Racer roller coaster, as seen in this picture, to make room for the Auto Race. A new park administration building was built on the site of the first pony track in 1938.

A small-scale Wells Fargo stagecoach was added during the 1950s and was a big hit during the era of movie and television westerns, which lasted until the 1960s. Children loved riding both inside and on top of the authentic-looking Western-style carriage. In 1975, the Log Jammer displaced the ponies to a new track behind the Skooter building on the old swimming-pool site. They were relocated one last time in 1980, traveling underneath the Laser Loop's track, until finally removed after the 1984 season, signifying the end of an era.

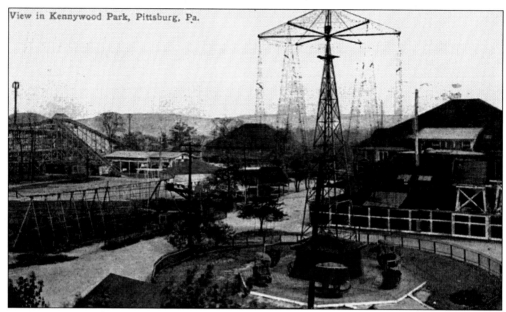

Two years after the Wright brothers made their first historic flight in Kitty Hawk, North Carolina, the park added its first circle-swing ride, in 1905. Called Air Ships, the ride featured six small covered gondolas made of wicker that were suspended by cables from a tall central tower. The cables of the air ships were attached to a circular set of spokes at the top of the tower, which rotated slowly, giving a thrilling, yet gentle, ride while in motion. (Dick Bowker Collection.)

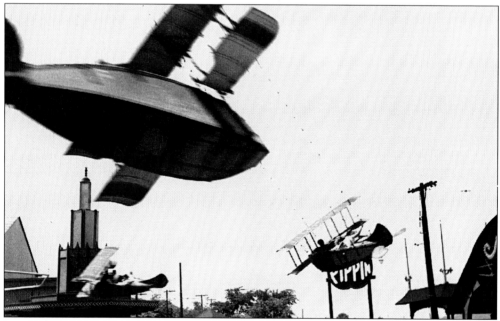

A new, larger circle swing was purchased in 1925 from Traver Engineering Company of Beaver Falls and featured seaplanes for the ride vehicles. It was located in a central area near the Bug House and Pippin roller coaster station and remained there through the 1939 season. (Charles Siple Collection.)

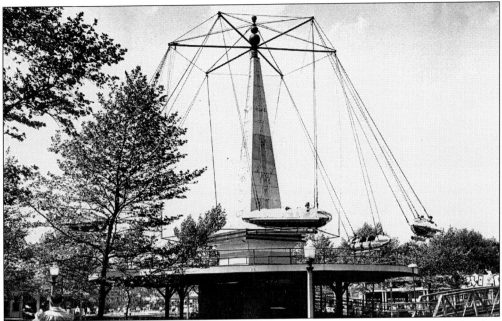

The circle swing was relocated to the small island in the lagoon across from Kiddieland in 1940. The park's ornamental windmill, which had occupied the island since 1928, was moved next to the ladies' cottage across from the Old Mill. The tower was raised about 20 feet, and an elevated platform and pedestrian bridge were erected over the lagoon. Replacing the seaplanes were shiny metallic rockets and a new park centerpiece was born.

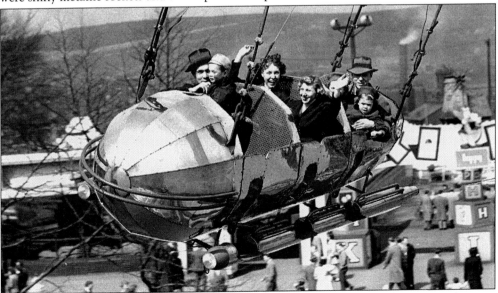

Rockets, as the ride was renamed, became a favorite for both young and old. The ride was a visual sensation from the ground and while riding and remained a popular ride for many years. The rockets flew over the lagoon for 28 years. But their popularity dwindled as newer, flashier rides were added to the park. In 1978, the rockets flew their last season and were replaced by the Monongahela Monster in 1979. The lagoon was shortened on one side, and the Garden Stage was built underneath the platform.

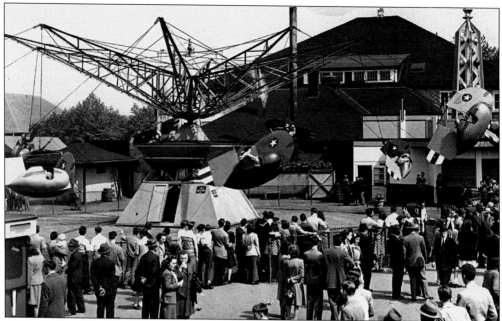

A Flying Skooter ride called the Dipsy Doodle replaced the circle swing when it was moved to its new lagoon island home. The Dipsy Doodle was a more thrilling version of the circle swing that featured small aircraft-like vehicles. These "cars" had large steering fins in front that gave riders the ability to swoop, steer, and dive while in flight. The ride was removed in 1962, but two other similar rides were installed in later years: the Flyer (1965–1972) and the Phantom Flyer (1995–1996).

One of the more unusual rides to be installed at Kennywood is the Aerotrainer. Added as a concession to the park during the beginning years of the Depression in 1931, it tried to capture the spirit of flight made famous by Charles Lindbergh's 1927 transatlantic crossing. Guests boarded the small, metallic airplane-shaped vehicle of the Aerotrainer, which performed such aeronautical stunts as dives and barrel rolls. As this picture suggests, it may have been too intense for passengers. It only lasted one or two seasons.

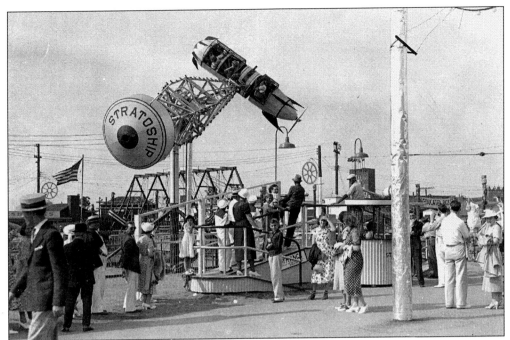

Long before America had created a space program, Kennywood installed the Stratoship ride in 1938. Would-be space cadets boarded a six-passenger Buck Rogers–style rocket vehicle and found themselves being tossed and spun around a central pylon. Like the Aerotrainer before it, the Stratoship proved to be too intense for the average park goer and only lasted a short while. It was reported to be a very loud and noisy attraction for those who remember it.

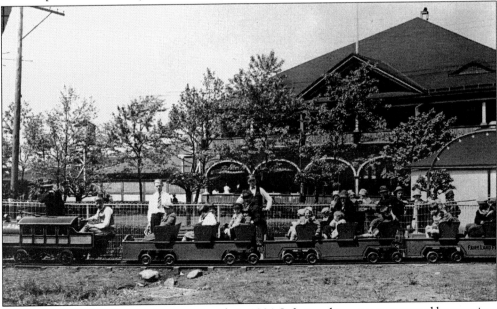

The park installed its first miniature train ride in 1904. It featured two steam-powered locomotives and was set in a scenic area next to the park's first pony track. A newer electric-powered railroad (pictured) was added in 1925 on the site of the old pony track, which was located near the Casino restaurant where the current park administrative office is today.

The newer train featured an electric-powered engine that received its power via a third rail in the middle of the track. Notice how the train's left side shared the middle rail with the outgoing track and the incoming track, which was probably a cost saver during installation. The miniature railway was moved next to the Auto Race when that ride was built in 1930. The new location offered passengers a more scenic view of the park and a brief glimpse of the river valley below.

A newer streamlined engine was purchased for the electric-powered miniature railway in 1940 in an attempt to update the small train ride. This new engine operated until the train was removed after the 1944 season. Up to that time, men had traditionally operated most of the rides in the park, but during World War II, women were hired to replace many of the men who were off fighting the war. Women employees have been operating rides along with their male counterparts ever since.

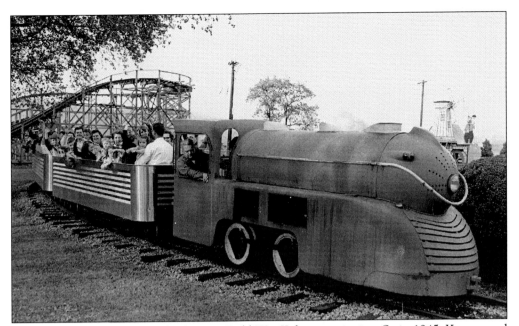

New rides were hard to come by during World War II due to rationing. So in 1945, Kennywood purchased a used ride to replace the old miniature railway. It was a larger, diesel-powered train ride that once ran at the 1939 World's Fair in New York. Known at the fair as the Gimbel's Flyer (of the department store of the same name), it offered guests an elaborate "Trip Around the World." It was renamed the Little Choo-Choo when it was installed at Kennywood.

The route for the new train ride ran behind Kiddieland along the bluff overlooking the Monongahela River (this picture shows it passing the windmill that was part of the Kiddie Old Mill ride). The train offered riders a spectacular view of the river below, including the lock and dam, the Edgar Thompson steel works, and the city of Braddock across the river. The train still runs today along this route, giving the same impressive view as it has for nearly 60 years.

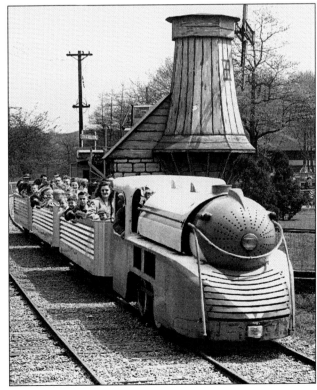

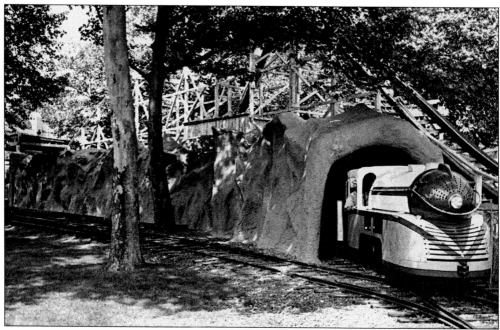

A long dark narrow tunnel was added to the train ride in 1964, adjacent to the Dipper roller coaster's lift hill. In 1967, the train ride became known as the "Ol' Mon River Railroad." A full-scale diorama reenactment of Braddock's Crossing during the French and Indian War was added to the turnaround loop at the far end of the track. The battle was recreated with sights and sounds, including musket fire and a burning wagon.

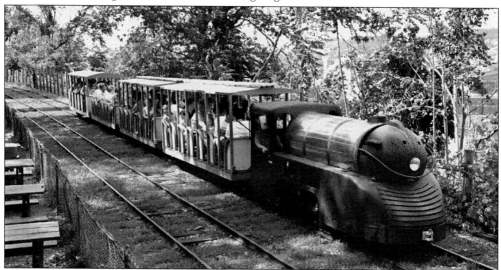

The miniature railroad was re-themed into Hoot n' Holler Railroad in 1976. A moonshine village replaced the Braddock's Crossing diorama and featured numerous animated moonshiners and hillbillies in a series of comical scenes. The railroad was re-themed yet again in 1993 as historical scenes of the Pittsburgh area replaced the aging (and less politically correct) hillbillies. The train ride was then renamed Old Kennywood Railroad. A prerecorded narration was added to the train ride for the park's centennial in 1998. (Photograph by Rick Davis.)

The automobile was becoming a popular form of transportation in the early 1900s. To cash in on this new craze, new automobile-inspired rides started appearing at amusement parks. In 1922, Kennywood added the Dodgem, an early form of bumper cars, which replaced the Gee Whiz Dip the Dips coaster. The object of the ride was to dodge the other drivers, not bump into them. The ride lasted until 1929, when the building was converted into the Laff in the Dark dark ride.

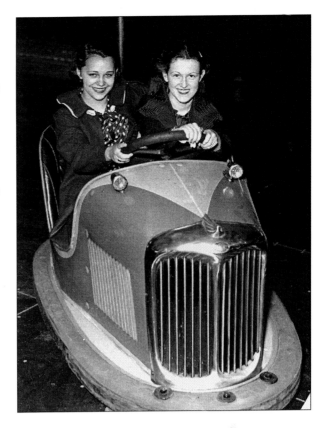

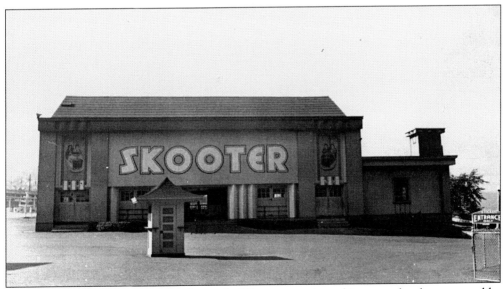

In 1936, the park's Bug House fun house building was converted into another bumper-car-like ride, the Skooter. Using the building's first floor only, the Skooter was a similar ride to the Dodgem in which the object was to not hit the other cars. The Skooter remained a park staple for 43 years, although the building received a modern-looking facade in 1971.

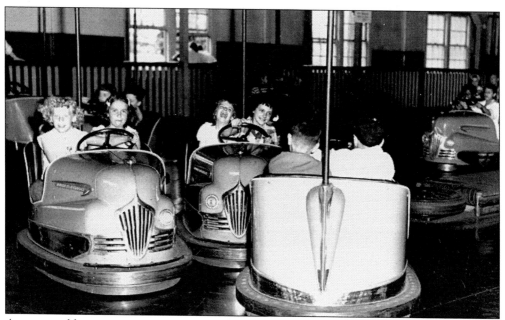

As one would expect, not everyone followed the rule to not bump into the other cars. As this picture from the 1950s shows, bumping seemed to be a lot more fun! The Skooter building and ride were removed at the end of the 1979 season. The historic building, which once housed the Wonderland, Daffy Dilla, Tut's Tomb, and Bug House fun houses, as well as the Skooter, was torn down to make way for the Laser Loop coaster, which opened in 1980.

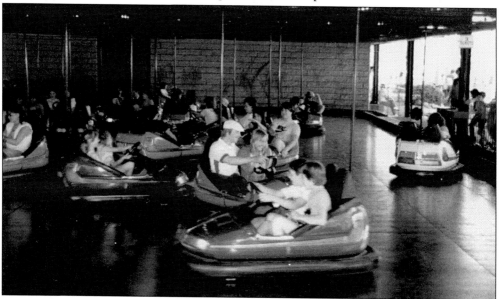

In 1973, a new set of bumper cars was purchased from a manufacturer in Italy. Unlike the Dodgems, or Skooters, the Gran Prix *allowed* bumping, including head-on collisions. A set of single-seat circular bumper cars operated in the Gran Prix building for the 1974 season. They were destroyed when the Ghost Ship, where they were stored after only one season of use, burned during the fire of 1975. The standard two-seat bumper cars seen in this 1985 picture are still used today. (Photograph by David Hahner.)

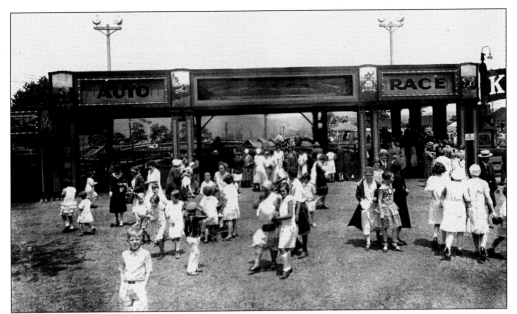

By the late 1920s, the automobile had become an extremely popular form of transportation. Although most people could not afford to own one at the time, it still sparked a national fascination. It seemed everyone wanted to drive, so in 1930, Kennywood installed the Traver Engineering–designed Auto Race, which gave young drivers their first chance to sit behind the wheel. It was located on the former site of the old Racer's station and lift hills.

The Auto Race proved to be a huge success during the years of the Great Depression. Originally, the Auto Race had a series of small hills on the track's straightaways. The hills were removed in the 1940s due to collisions with the vehicles when the track became wet. Aside from the hill removals, the layout for the ride has remained unchanged since its installation in 1930. During the 1950s, the name of the Auto Race was changed to Auto Ride.

The cars were redesigned into a more streamlined style in 1948 and the hills were removed from the track. This photograph from the early 1970s shows off three great family rides from that period. The Auto Ride zips around its wooden track while the Ol' Mon River Railroad returns to the station behind it. Racing over its track in the background, the Dipper is delighting another coaster train full of young thrill seekers.

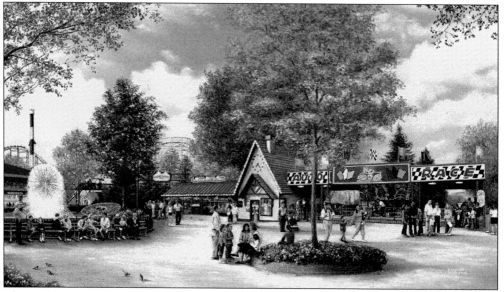

The Harry Traver–designed ride was named back to Auto Race during the 1990s. The cars now sport racing numbers on their bodies, and the loading station's facade was redone with a new racing motif, complete with an animated neon race car that was originally added to the front in the 1950s. Artist Linda Barnicott captures the current facades for the Auto Race and train station perfectly in this handsome 2002 print. (Linda Barnicott Publishing.)

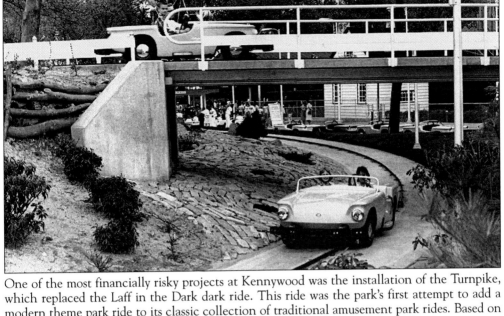

One of the most financially risky projects at Kennywood was the installation of the Turnpike, which replaced the Laff in the Dark dark ride. This ride was the park's first attempt to add a modern theme park ride to its classic collection of traditional amusement park rides. Based on the popular Autopia attraction at Disneyland in California (as well as similar attractions at other theme parks), the Turnpike featured small, two-passenger, gas-powered automobiles that were kept on the ride's course via a center guide rail.

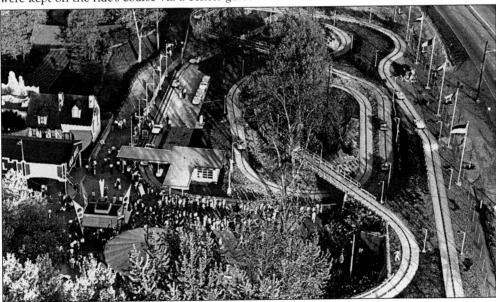

The Arrow Development–designed Turnpike vehicles traversed a heavily landscaped miniature highway system. Since the park's owners did not yet own the land on which the park was built, adding such an expensive (and permanent) addition seemed almost foolhardy. The ride became an instant success, and Kennywood management eventually purchased the park's land in 1970. The Turnpike sits to the right of the Old Mill and was designed to be intentionally visible from Kennywood Boulevard.

In 1987, Kennywood removed the gasoline-powered cars of the Turnpike and replaced them with newer, antique-looking electric models built by Morgan Manufacturing. An electric rail that supplies power to the cars was added to the middle guide rail. The replacement automobiles travel the same course but in the opposite direction of their gasoline predecessors. (Photograph by David Hahner.)

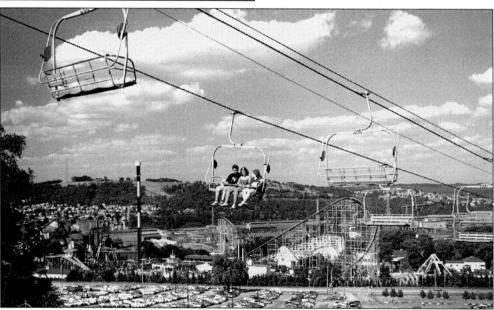

As the park added bigger and better rides over the years, attendance increased as well. With Lost Kennywood replacing the pay parking lot, more parking had to be added on the hillside across from the park. The hillside was gradually tiered to three levels of parking. It was decided in 1996 to add a ski lift, called Kenny's Parkway, to help transport the people from the top parking area to the park's entrance below, free of charge. The ride offers one of the most scenic views of the park as you descend toward the entrance.

Eight

MAKING A SPLASH
AT KENNYWOOD

Keeping cool in the hot summer sun has always been an important part of Kennywood's appeal. In the early years, visitors to the park remained cool by relaxing next to the park's central lagoon, picnicking under one of the many shade trees, or by taking a ride aboard the park's carousel, coasters, or other early amusement rides. In 1925, keeping cool took on a completely different meaning with the opening of the park's immense swimming pool. Considered one of the largest pools in the country when it was built, Kennywood's pool attracted millions of swimmers in its almost half-century of operation. Many who were able to splash in its 2.5 million gallons during this time period have remembered it fondly. Unfortunately, the pool required a lot of money to maintain and repair and ultimately closed after the 1973 season.

But other forms of water recreation were added to the park after the pool's closing. Although the Old Mill is the park's original water ride, it was never designed to get passengers wet. The Log Jammer, which opened in 1975, changed this. This modern-day log-flume ride, which was the park's first ride to cost more than $1 million, gives passengers gentle splashes of water during the course of the ride. The addition of the Raging Rapids whitewater raft ride 10 years later intensified the wetness factor many times over as riders often come off soaked rather than just wet.

In 1995, the park installed its wettest attraction ever with the addition of the Pittsburg Plunge. It is a modern version of the old-style Shoot the Chute rides from the turn of the 20th century. This new version of an old favorite drops riders down a large chute, creating a huge wall of water that not only drenches the riders in the boat but also any onlookers standing too close to the splashdown pool.

What sets the Pittsburg Plunge apart from other rides added to Kennywood is that it was the focal point of a new themed area of the park that was built on the site of the old swimming pool. Titled Lost Kennywood, it was the park's first truly themed section and featured rides and architecture that could be found at many defunct amusement parks from around the northeastern United States, including parks in the Pittsburgh area. Buildings representing Pittsburgh's lost West View Park, Luna Park, and White Swan Park, as well as other regional parks, (such as Idora Park in Youngstown, Ohio) were created. Classic current Kennywood rides, such as the Whip and Wave Swinger, were moved into Lost Kennywood. Other long-lost rides such as the Flying Skooter (also known as the Dipsy Doodle, or Flyer) and the Roll-O-Plane returned to the park for the first time in years. And as a tribute to the park's original swimming pool, a reproduction of the pool's fountain is found there.

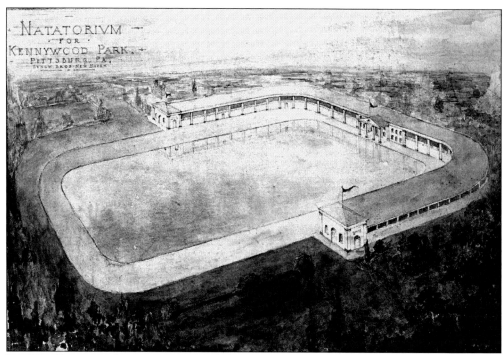

In 1924, Kennywood management decided to build a huge swimming pool on the location of the athletic field, which was later moved across the road and trolley tracks into a section of the large parking lot. This preproduction rendering from 1924 shows the immense size and scope of the project, which was designed by Lynch Brothers of New Haven, Connecticut, dubbed "Nautitorium."

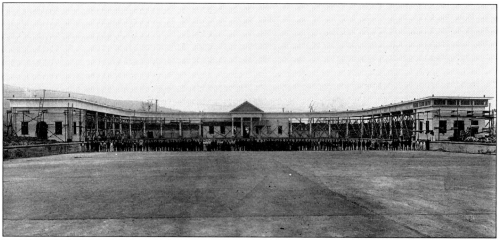

By May 1925, the new unnamed swimming pool was near completion. The pool measured 350 feet by 180 feet and was one of the largest swimming pools built at that time. A large U-shaped bathhouse was located at the far end of the pool. Atop the bathhouse was a huge grandstand area for spectators, some of whom came to the pool only to watch others swim.

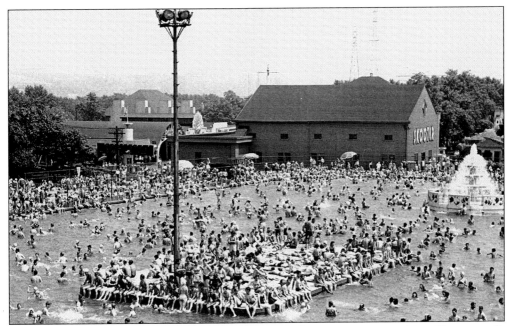

The pool was almost an instant success and remained an important staple in Kennywood's entertainment roster for nearly 50 years. The pool, along with the park's live entertainment, helped to keep Kennywood afloat during the Depression years. Despite its continuing popularity, as seen in this early-1940s photograph, the pool was never a huge moneymaker because of increasing maintenance issues. This would eventually be the major factor in the decision for the pool's closing in later years

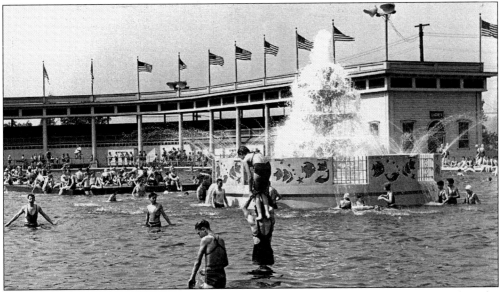

A large ornamental fountain was added in 1937 and became a major focal point within the pool. The squirting jets of water that surrounded the cascading central fountain offered a refreshing way to stay cool in the hot sun. It also featured spectacular lighting effects at night, even after the pool closed for the day. This fountain was later re-created in the Lost Kennywood section of the park, which opened on the former pool's site in 1995.

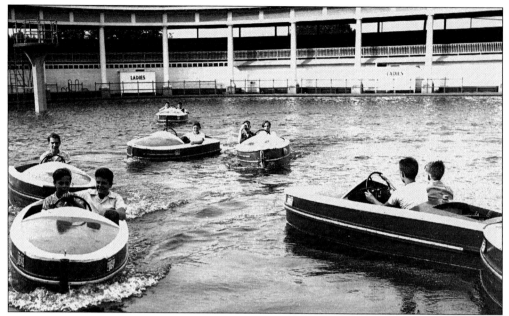

In 1953, despite its popularity, the pool closed to bathers due to filtration and maintenance problems, including large cracks and leaks. As a temporary fix, the park added a U-Drivem Boat concession within the pool. After carefully considering the possibility of permanently closing the pool in 1955, park management decided to rehab and repair it instead. After the extensive repairs were completed, the swimming pool once again reopened for bathers and became known as the Sunlite Pool.

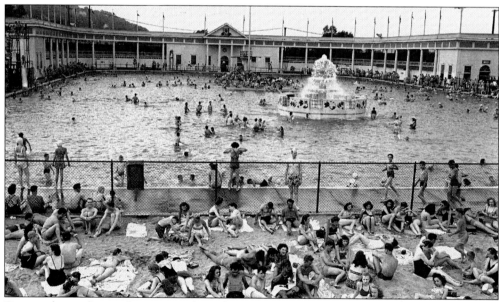

Despite the pool's popularity, even through the 1973 season, management decided to close it, once and for all, after the season ended. The decision to close the pool was mainly an economic one as major water leakage had developed due to mine subsidence and age. The historic bathhouse and grandstand were torn down, the fountain leveled, and the pool was filled in. It became an expansion for the adjacent pay parking lot and remained a parking lot until 1991.

Today, the spirit of Kennywood's swimming pool lives on in the development of the Sandcastle Waterpark in nearby West Homestead, along the shores of the Monongahela River. Sandcastle, part of the Kennywood Entertainment family of parks, opened in 1989 and features 16 water slides, a children's water play area, go-kart tracks, two swimming pools (including a huge modern wave pool), and a turn-of-the-20th-century boardwalk area.

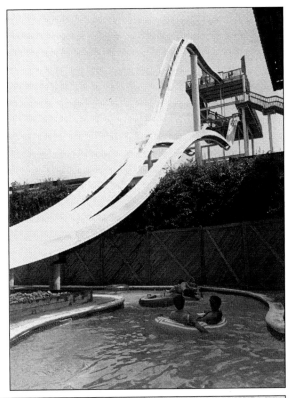

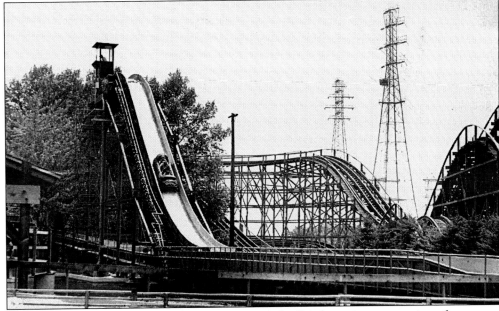

With the closing of the pool in 1973, Kennywood offered no water attractions for patrons to cool off. In 1975, this changed with the addition of the Log Jammer flume ride. The Log Jammer was the park's first ride to cost in excess of $1 million. The new water ride displaced the pony track to an area behind the Skooter building, which occupied a small area where a section of the pool had once been located.

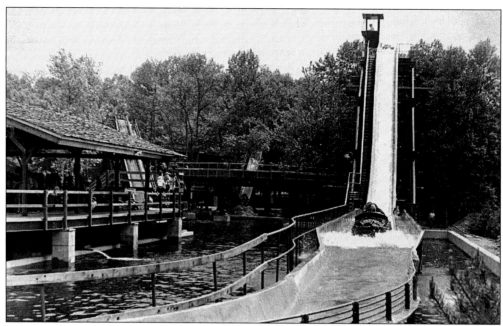

The Log Jammer was Kennywood's first major theme park–style attraction to be added after park management had finally purchased the park's land in 1970. No longer tenants on leased property, management was now free to build up the park with higher-cost attractions, thereby competing with larger regional parks. The addition of the Log Jammer also signaled the demise of longtime Pittsburgh competitor West View Park, which closed just two years later in 1977.

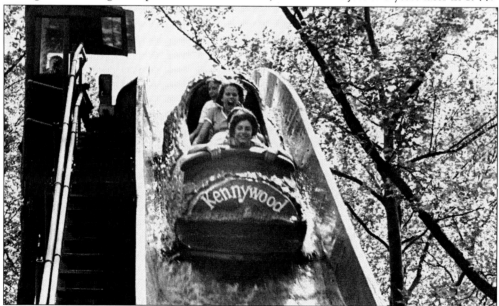

Built by Arrow Dynamics of Clearfield, Utah, Log Jammer became an instant success. Arrow was the company that invented the modern log flume ride in the early 1960s. By the mid-1970s, log flumes had become a modern theme park standard. Arrow was also a major ride designer for Disneyland and Walt Disney World and later designed and built Kennywood's Steel Phantom coaster in 1991.

With the success of the Log Jammer, Kennywood management set forth to add the park's second major water ride addition, Raging Rapids, in 1985. Simulating a whitewater rafting adventure, Raging Rapids quickly became the park's wettest addition. Unlike the Log Jammer, which generally only sprays water on its passengers, Raging Rapids douses and drenches its riders almost completely. Unfortunately, to make way for the new ride, the Starvue Plaza stage, Cuddle-Up ride, and Dipper roller coaster had to be removed. (Photograph by David Hahner.)

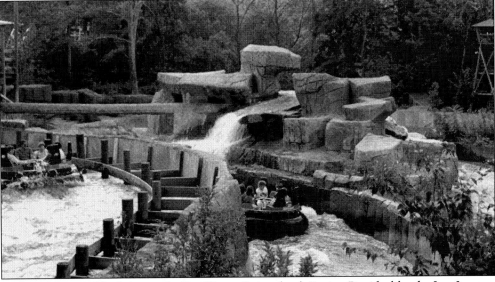

Built and designed by Intamin A. G. of Bern, Switzerland, Raging Rapids, like the Log Jammer before it, became an instant wet sensation. Getting soaked or getting slightly wet on Raging Rapids is pure chance. Part of the fun of the ride is watching fellow passengers get doused by the various waterfalls, rapids, or geysers along the course of the man-made waterway. Chances of staying relatively dry are possible, but rare. Often, complete drenching is the more common result of challenging the whitewater of Raging Rapids. (Photograph by David Hahner.)

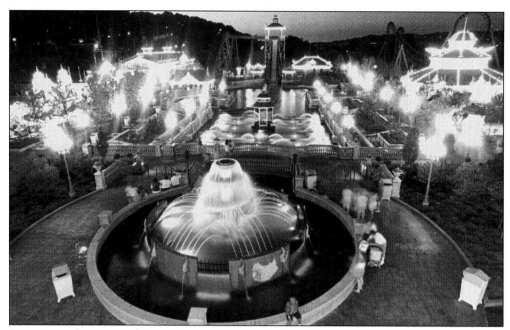

Bruce D. Robinson Architecture of Cincinnati was hired by park management in the early 1990s to redesign the entire former swimming-pool area that was then being used as a pay parking lot. For the first time, Kennywood added a completely themed area to the park, which became a symbolic tribute to long-past Pittsburgh-area amusement parks. The new theme area, which opened in 1995, was named Lost Kennywood and became the largest single addition in the park's history.

Guests enter the themed area through a faithful reproduction of an ornate, classical archway that was once the main entrance for Luna Park, a long-lost Pittsburgh amusement park that was located in the Oakland section of the city during the 1910s. Luna Park was based on the original park of the same name, which was once part of Coney Island. Instead of displaying the name Luna Park, the new archway proclaims "Pittsburg's Lost Kennywood" with the *h* in Pittsburgh purposely omitted for historical accuracy.

The centerpiece of Lost Kennywood is a large reflecting pool housing a modern Shoot the Chutes attraction, which was built by the O. D. Hopkins Company of New England, called Pittsburg Plunge. It was inspired by the Shoot the Chute ride that was once the centerpiece attraction at Pittsburgh's old Luna Park. (Photograph by Rick Davis.)

Unlike its century-old predecessors, which gave riders a mild spray of water, this newly designed chute ride drenches riders with an enormous wave of water when the boat splashes down. Even curious onlookers who get too close to the splash zone will find themselves drenched in a torrent of water. (Photograph by Jim Futrell.)

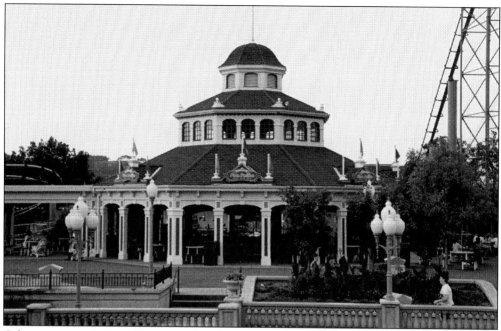

Other structures in Lost Kennywood are representative of buildings of other area amusement parks that have since closed. This structure, which houses a refreshment stand, is built to look like West View Park's carousel building. West View Park, once located in the north hills of Pittsburgh, was Kennywood's main area rival until it closed in 1977.

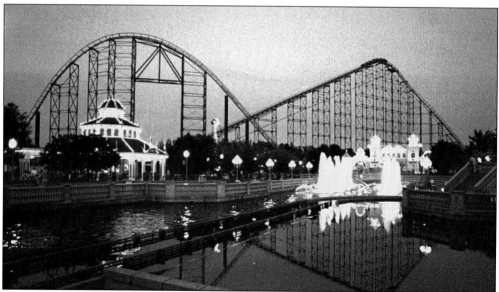

Ironically, the debut of Lost Kennywood was delayed one year because of the former occupant of the area. Due to the fact that the swimming pool was mostly filled in instead of removed when it closed, much of what remained of the pool had to be dug out to create the foundation for the reflecting pool and splash pool of the Pittsburg Plunge. This beautiful night shot showcases some of the wonderful lighting found in Lost Kennywood. (Photograph by Rick Davis.)

Nine

PINT-SIZED THRILLS: KIDDIELAND MEMORIES

Although Kennywood has always been an entertainment center suitable for all ages, it was not until 1923 that the first ride designed exclusively for use by small children was installed. The addition of the park's first kiddie carousel signified the start of a new era at the park. One year later, three more kiddie rides, a Swan Swing, a kiddie Whip, and a kiddie Ferris wheel were purchased. The four rides were grouped together across from the Jack Rabbit roller coaster to form the park's first "kiddieland." In 1927, during the largest expansion in the park's history, the larger Kiddieland was created on the site of the playground that once sat between the old Racer roller coaster and the dance hall building. The new area consisted of eight rides, including four additional new rides. The first kiddie carousel, which had only two rows of horses, was replaced with a larger three-row model. Both the kiddie Ferris wheel and this second carousel still delight children today.

Over the years, Kiddieland changed as the times changed. During the Great Depression, no new rides could be afforded, so the existing playground equipment was featured as a free attraction. After the Depression ended in the mid-1930s, the park once again began to add and upgrade rides both in the main park and in Kiddieland. The addition of the Kiddie Old Mill, pony carts, and Roto-Whip helped signify that the park was back in business as usual. Unfortunately, the events of World War II once again proved to be a setback for the park as no new rides were available during that period. However, it was what occurred after the end of the war that transformed Kiddieland forever. The post-war baby boom increased attendance to Kiddieland, and to Kennywood, like never before. More rides were added and Kiddieland expanded once again. As many as 16 kiddie rides were located in Kiddieland during the height of the baby boom in the 1950s and 1960s.

In 1975, Kiddieland suffered the loss of two rides, including the original classic kiddie Whip from 1924, when the dance hall building burned to the ground. Just like the rest of the park, Kiddieland continued to transform during the remaining decades of the 20th century. Older rides were replaced with newer ones. The beloved lost kiddie Whip was even replaced. As the 21st century dawned, newer family-style kiddie rides in which parents could ride with their children emerged. Comic-strip favorites Garfield and Odie soon made Kiddieland their home as the children's area once again adapted to an ever-changing world. Once painted on the entrance to Kiddieland was the phrase "The Most Beautiful Music in the World is the Sound of Children Laughing." And for as long as there are young children visiting Kennywood with their families, forever will there be Kiddieland.

One of the park's first kiddie rides was a kiddie carousel that was built by the W. F. Mangels Company of Coney Island. This two-row model was purchased in 1923 and served as the foundation of a four-ride Kiddieland that opened in 1924 across from the Jack Rabbit, where a refreshment stand is today.

A kiddie Ferris wheel, also built by Mangels, was another of the rides that made up the park's original Kiddieland. The other two rides were a kiddie Mangels Whip and Swan Swing. The Ferris wheel, Swan Swing, and Whip were used as the cornerstone for the park's newer and bigger Kiddieland, which opened in 1927. Although the kiddie Ferris wheel was last retrofitted with new gondolas during the 1950s, it still thrills young riders today.

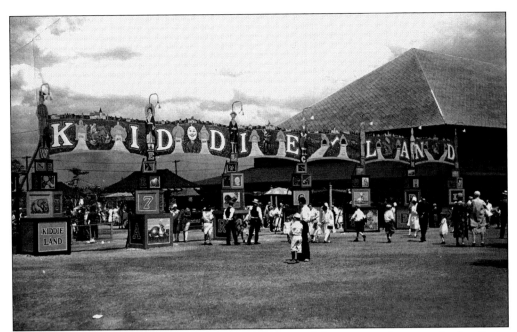

In 1927, Kiddieland was moved to the site of a playground that once sat between the first Racer coaster's station and the dance hall. The old Racer coaster was torn down after the 1926 season, replaced temporarily by the pony track. Kiddieland featured a colorful new entrance made up of giant toy blocks. Four new rides were added to the area, creating a miniature amusement park within an amusement park just for the little ones.

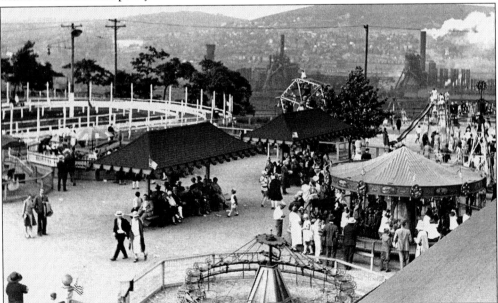

Kiddieland in 1927 was a busy place. Among the new rides were a miniature Aeroplane circle swing, a circular baby swing, and a brand new three-row Mangels kiddie carousel. The carousel, like the Ferris wheel, continues to delight little riders at the park today. A new Brownie electric roller coaster was added a year later alongside the pony track. The pony track was replaced with the Auto Race in 1930.

A kiddie Tickler ride was installed in 1931 and was the last kiddie ride added until the end of the Depression. It was located originally to the right of the Auto Ride but was then moved farther back into Kiddieland. This F. W. Mangels coaster-like creation featured small four-to-five passenger tubs on casters that freewheeled and spun wildly like a ball in a pinball machine down a winding zigzag track. This unique, one-of-a-kind kiddie ride was removed in the early 1950s and replaced by a children's rest room.

As the Depression was coming to an end, new attractions were added throughout the park, including Kiddieland. The first permanent ride added to the area was the Kiddie Old Mill in 1937. Built by the Philadelphia Toboggan Company, the Kiddie Old Mill was based on the park's larger Old Mill ride and featured small wooden boats with hand-carved swan heads adorning the boat fronts. The boats followed a gentle current of water through a concrete trough, past well-manicured landscapes and shrubbery.

The Kiddie Old Mill remained a popular ride throughout its existence. However, wandering little fingers and hands sometimes got caught or scraped between the small wooden boats and the concrete walls of the trough. Although children were told to keep their hands on their lap at all times, curiosity sometimes got the better of them. Sadly, for this reason and rising maintenance costs, the ride closed in the mid-1970s. The trough was removed and filled in, but the little Dutch mill remained alone for many years until it was demolished in the mid-1980s.

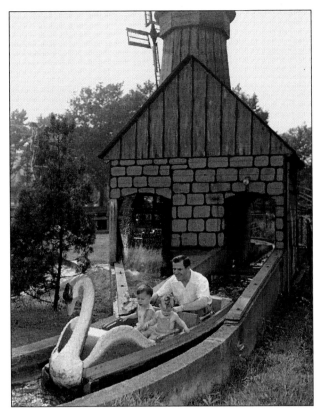

By 1950, Kennywood was beginning to feel the first benefits of the postwar baby boom as the children that were born after 1945 became old enough to ride. Throngs of families with young children came to the park. Since the area steel mills were thriving, business at the park was also benefiting. In 1950, Kiddieland began to transform and grow. A new entrance featuring giant toy soldiers greeted the young visitors as they entered Kiddieland.

As was typical with the kiddie rides, a smaller version of an old park favorite, the Turtle (Tumble Bug), was added in 1950. The kiddie Turtle, built by R. E. Chambers of Beaver Falls, featured three small turtle cars that traversed two small hills. The ride has remained one of the most popular kiddie rides in the park and one of the few older kiddie rides that allow parents to ride with their children.

In 1953, Kennywood added a new high-tech kiddie ride with the addition of the Rodeo. Built by the Allan Herschel Company of Tonawanda, New York, Rodeo was a circular horse ride. The object of the Rodeo ride was to shoot the bandit targets located in the center of the ride. The guns actually used an electronic beam of light that activated a bell if the targets were hit. Rodeo lasted only three seasons and was removed in 1955.

Also in 1953, a set of kid-powered Hand Cars were installed. The dual-railroad track-like ride allowed children to race one another along the short course. The Hand Cars remained a very popular attraction for many years until they were moved to Idlewild Park in the 1980s. At Idlewild, some of the cars were converted into adult-sized models in 1991 for the park's kiddie area, Raccoon Lagoon, to allow adults to ride with their children. The kiddie Roto-Whip can be seen in the background as well.

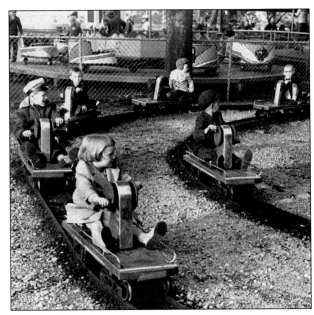

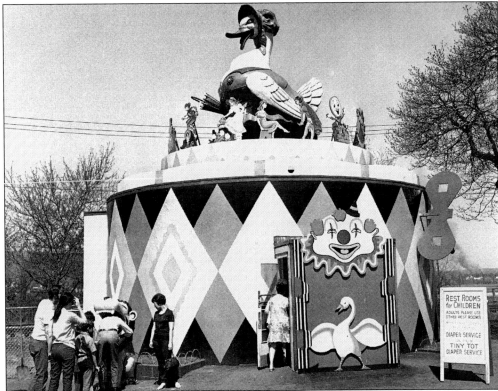

With the growing number of children coming to the park during the baby boom years, it was necessary to add a children's rest room building. But this was no ordinary rest room. The circular building was made to look like a giant wind-up toy. A large red key revolved as if winding the toy. On top of the structure, a large Mother Goose figure rotated in one direction and storybook characters revolved in the opposite direction.

117

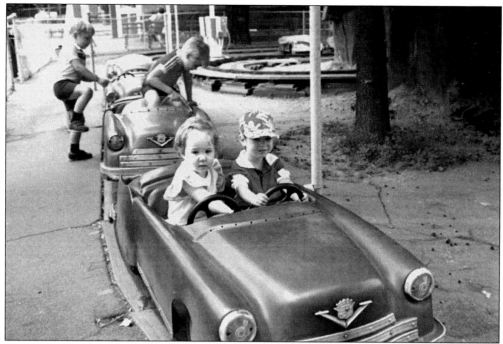

One of the most popular kiddie rides installed was the Kiddie Turnpike, which also was known as the Kiddie Cadillacs. These zippy little two-seater cars have been traveling through Kiddieland since 1955. The cars travel through a small man-made mountain tunnel and across a small bridge along their wooden-tracked course. The ride was manufactured by B. A. Schiff Company, which also built the park's original Wild Mouse coaster. (Photograph by David Hahner.)

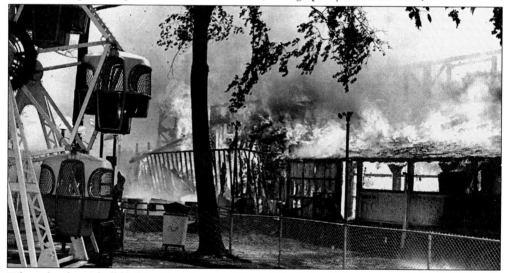

When the dance hall building housing the Ghost Ship dark ride burned to the ground in June 1975, adjacent Kiddieland was not without loss. Two of the parks more popular kiddie rides were lost: the German vehicle carousel and the park's original 1927 kiddie Whip. Although the original kiddie Ferris wheel (seen with its 1950s-era gondolas) was close to the flames, it fortunately was spared. A new entrance to Kiddieland was constructed one year later where the dance hall building was once located.

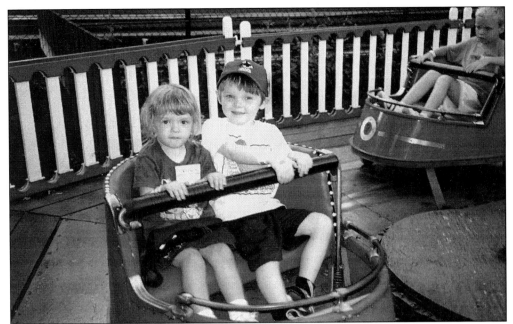

In 1986, Kennywood acquired an antique Mangels kiddie Whip from the defunct Paragon Park in Hull, Massachusetts. It was similar to the model that the park lost in the 1975 fire and was installed next to the original kiddie Ferris wheel and carousel, creating a mini-historic-rides area in Kiddieland. The acquisition allows a new generation of children to experience the same thrills that their parents and grandparents did when they visited the park as children. (Photograph by David Hahner.)

A new trend in children's rides began in the 1990s, as parks began to install kiddie rides that the whole family could ride together. Italian ride manufacturer Zamperla was one of the pioneers of this type of ride. Kennywood's first family Kiddieland installation was the Crazy Trolley in 2001. The ride was themed to a turn-of-the-century trolley that once brought guests to the park. The gentle thrill ride takes guests up and down in a 360-degree vertical rotation. (Photograph by David Hahner.)

Another Zamperla family installation is Garfield's Pounce Bounce that was added in 2002. Little guests and their parents can enjoy this tower ride together. The 16-passenger, elevator-like vehicle is taken approximately 30 feet up a tower and then bounces down. It gives a gentle stomach-dropping sensation similar to larger drop tower rides such as Kennywood's Pitt Fall. (Photograph by David Hahner.)

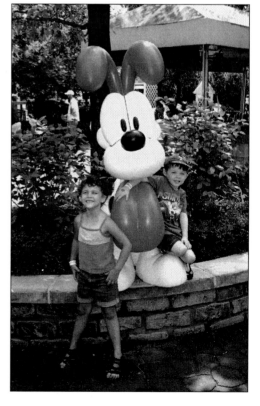

Kiddieland underwent a slight expansion with the addition of a new park-like garden in the center of Kiddieland in 2002. One year later, fiberglass figures of Garfield and Odie were placed in this area to allow children to interact and pose with the famous comic-strip duo. Also in 2003, their likenesses were added to the front of the kiddie rest room to help update Kiddieland's appearance. The addition of Garfield and Odie is just another phase in the ever-changing appearance of Kiddieland. (Photograph by David Hahner.)

Ten

ROUNDING IT ALL UP

Kennywood has been home to so many different types of rides over the years that it would be nearly impossible to list them all. This chapter, however, gives a brief overview of some of the unique and memorable rides that have called Kennywood home. Most of the rides that sit relatively low to the ground and can be dismantled easily are typically called "flat rides" within the amusement industry. Flat rides can be made up of most any type of ride, but spinning rides tend to make up the majority of them at amusement parks, including Kennywood. However, not all flat rides are spinning rides. It is just a term to classify most rides that defy some sort of classification. This chapter will try to cover some of these favorite flat rides, such as the Whip and the Turtle, as well as other types of rides, including the park's Ferris wheels, the thrilling Skycoaster, and the towering free fall ride known as Pitt Fall

Diversity of experiences has always been one of the most important things that has made Kennywood such a favorite for generations. As with most amusement parks, thrill rides tend to dominate the midways of Kennywood but not completely. The park has offered a little bit of everything over the years: fast and slow rides, tall and short ones, wet and dry. But what really makes Kennywood unique is that it mixes state-of-the-art thrill rides with old favorites that have thrilled visitors for generations. This philosophy, as well as the park management's commitment to preserving the unique attractions of the past, is the reason why Kennywood was designated a National Historic Landmark by the National Park Service in 1987, one of only two amusement parks to receive this prestigious honor.

The author hopes this book has sparked some old and fond memories that may have faded over time and can now be cherished again and again. This compilation has shown some of the many and diverse entertainments that the park has offered over the decades, proving that there truly is something for everyone at Kennywood. It is because of this rich diversity that Kennywood has become known as "America's Finest Traditional Amusement Park."

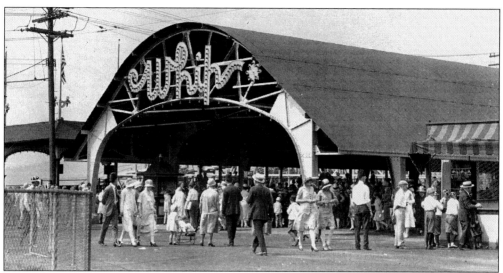

The oldest flat ride that is still in service in the park is the Whip. A 12-car version built by W. F. Mangels was purchased in 1919. A larger 16-car version was installed in this building in 1927 located next to the Pippin station. During the 1930s, a large band organ played at the far turn of the Whip's platform but was removed due to the loud noise of the ride. The Whip ride and building were moved near the Racer in 1968, when the Pippin was enlarged to become the Thunderbolt.

The Whip utilizes a long platform with two large wheels on either end. The cars are attached to a long cable and are swung in a whip-like motion while negotiating both turns. Today, guests still enjoy the tummy-tickling sensation of being whipped around each end of the platform just as earlier riders did years before. The ride was moved to its new location in Lost Kennywood in 1995 and operates virtually the same as when it first opened in 1927 to the delight of its riders. (Thomas Hahner Collection.)

Another old park favorite that still exists at Kennywood is the Tumble Bug, now known as the Turtle, which also opened in 1927. Traver Engineering of Beaver Falls manufactured this popular ride, which features six large round cars that traverse a circular track with three large undulating hills. The hills, which range about 10–15 feet in height, are thrilling enough for the adventuresome, yet tame enough for the squeamish.

In 1948, the bug-like vehicles were replaced with turtle-shaped ones built by R. E. Chambers of Beaver Falls, and a new animated neon sign was installed in front of the ride when it was renamed the Turtle. Today, the Turtle, along with the Whip, remains one of the most popular historic flat rides in the park and is usually a favorite among families with young children. It is one of only two Traver Tumble Bug rides still in operation in the country.

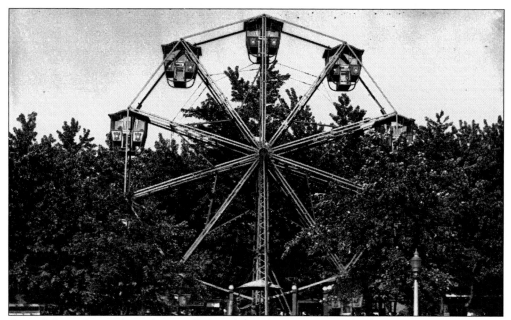

One of the earliest rides to be installed in the park was a Ferris wheel in 1903. In 1927, a new wheel (pictured), built by C. W. Parker of Kansas, was another major ride addition to the park during that great expansion year. It was only fitting to have a Ferris wheel in the park since George W. Ferris, the man who invented the ride as a centerpiece for the Chicago World's Fair of 1893, hailed from Pittsburgh.

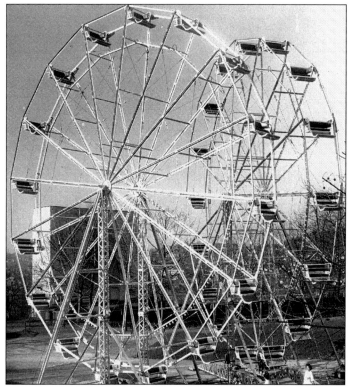

Two large Eli Bridge wheels were added in 1959, replacing a previous wheel that was also manufactured by the Eli Bridge Company of Jacksonville, Florida. That single wheel was installed in 1940 as a replacement to the aging Parker-manufactured Ferris wheel. The two new wheels were located near the Pippin and band shell. One wheel was sold, and the other was moved next to Noah's Ark in the early 1970s. The remaining wheel was removed after the 1980 season.

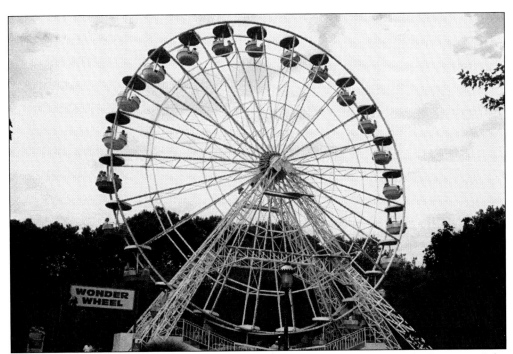

A large, 85-foot-diameter Ferris wheel was installed in 1986, not far from the location of the park's first wheel near the lagoon. Dubbed the Wonder Wheel, it featured 24, six-passenger gondolas and a computerized lighting program that provided spectacular patterns of light during the evenings. The ride offered stunning views of the park and the Monongahela River valley. It was removed after the 1999 season, replaced with the Aero-360 ride in 2000.

In 2000, the park installed a Zamperla-manufactured Hawk ride, whose arms were themed to look like gigantic versions of the famed Kennywood-logo directional arrows. The ride was named Aero-360, for the airborne sensation it provides, as well as for the unique Kennywood logo. Riders' legs dangle freely as the two huge 70-foot-long arms swing riders upside down in a 360-degree arc. Even in this winter photograph, the Aero-360 looks imposing, though dormant for the season. (Photograph by David Hahner.)

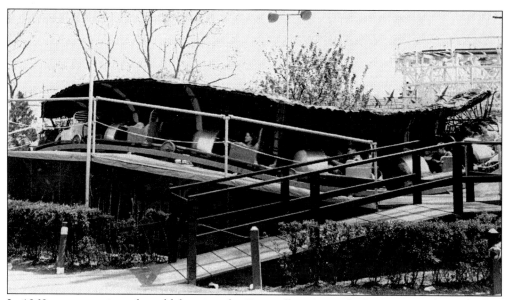

In 1969, a new version of an old favorite, the Caterpillar, returned after a 24-year hiatus. Allan Herschell Company of Tonawanda, New York, built this newer edition of a park classic that features a ring of cars traveling over a circular, undulating track. Midway through the ride, a canvas canopy encloses riders giving the appearance of a large caterpillar. Although the popular ride was removed in 1983, a similar one still operates at Kennywood's sister park, Idlewild Park in Ligonier.

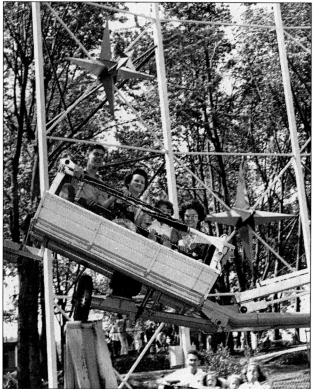

A Norman Bartlett–designed "flying coaster" ride was installed in 1962, which the park called Kangaroo. This unique round ride features one small ramp along its circular course that sends the ride vehicles flying off the ramp's edge, creating an unusual jumping sensation. The Kangaroo has remained one of the park's favorite flat rides and is the only one of its kind in permanent operation in an amusement park today.

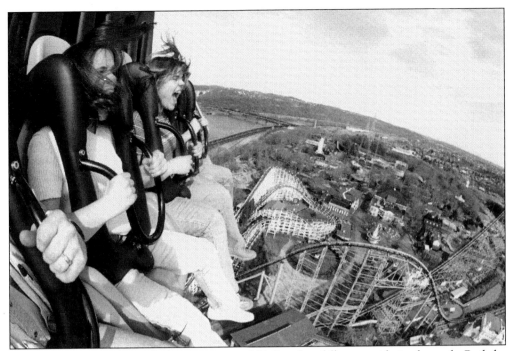

In 1997, Kennywood installed an enormous, 251-foot free fall tower ride in the park. Built by Intamin A. G. of Switzerland, the alternating black-and-gold tower replaced the Phantom Flyer flying-skooter ride in Lost Kennywood. Four, 4-passenger vehicles are pulled to the top of the tower, giving an awe-inspiring, but brief, view of the park and surrounding area. Then, almost without warning, the cars drop down the side of the tower causing momentary weightlessness for the passengers. Magnetic brakes stop the cars safely at the bottom.

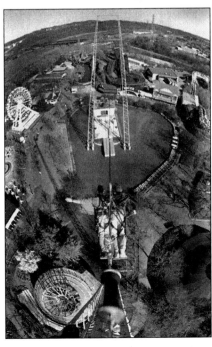

For 66 years, the park payed circus artists to perform daring, death-defying feats above the park's lagoon. With the addition of the Skycoaster, guests pay to do an equally thrilling act but are thoroughly safe. Attached to a long cable that is hoisted 200 feet into the air, guests swing in a huge arc above the former lagoon stage, which gives riders the thrill of flying. To those on the ground, the new attraction can be as entertaining as the circus acts that came before.

In 2003, Kennywood created their second themed area with the addition of a Huss Top Spin from Germany. The new area is called Volcano Valley, which features a tropical-island theme. The existing Enterprise ride became an erupting Volcano, complete with light, sound, and smoke effects. The neighboring Pirate swinging ship ride also received an extensive makeover that added realistic pirates surrounding the ride's base. The new Top Spin (pictured) became the King Kahuna, which flips riders mercilessly while occasionally drenching them with water. (Photograph by David Hahner.)

All good things must come to an end and so must our visit to Kennywood. Many guests have reluctantly trekked back through the entrance tunnel after having an exciting and memorable day in the park. The sounds of the rides begin to fade, our bellies are full from all the wondrous treats we have savored, and our feet are tired from the miles we have hiked while going from one adventure to the next. But we know someday we will return to make new memories that we will cherish with an old friend named Kennywood.